IMAGES OF ENGLAND

CENTRAL
LEEDS

IMAGES OF ENGLAND

CENTRAL LEEDS

ROSE GIBSON AND MICHELE LEFEVRE

TEMPUS

Frontispiece: The premises of Stead & Simpson at the junction of Briggate and Kirkgate, *c.* 1900. Above the shop a large sign on the property points to the business of McDonalds Artificial Teeth Manufacturers at 136 Kirkgate. (Photograph from the McKenna Collection in Leeds Local Studies Library.)

First published 2006

Tempus Publishing Limited
The Mill, Brimscombe Port,
Stroud, Gloucestershire, GL5 2QG
www.tempus-publishing.com

British Library Cataloguing in Publication Data.
A catalogue record for this book is available from the British Library.

ISBN 0 7524 4005 5

Typesetting and origination by Tempus Publishing Limited.
Printed in Great Britain.

Contents

Acknowledgements

Research and indexing on the Leodis website, from which most of these photographs have been selected, has been done by members of the Leodis project team, in particular Christine Lovedale and June Brook. Their dedication and skill has made the website a huge resource for anyone interested in Leeds and its history. The information they have provided has proved invaluable in putting together this book. Similarly the high quality and depth of the research done by Suzanne Grahame for the Discovering Leeds section of the Leodis site has helped form the contents of this book. Some of the facts she unearthed have been reproduced in the captions. Gren Wilson and David Sheard have provided enormous help and expertise in scanning the photographs and providing superb photograph copies of the original images.

The partners in the Leodis project – Leeds Civic Trust, the Thoresby Society, West Yorkshire Archives Service and Leeds Museums and Galleries – have all provided great help and expertise in selecting photographs for the site and in allowing us to reproduce some of their images in this book. Thanks must also go to Yorkshire Post Newspapers and Associated Newspapers who have been generous in allowing us to reproduce some of their copyrighted material held in our collections.

All images are copyright Leeds Library and Information Service except those listed here: Thoresby Society: p.13 bottom; p.14 top; p.15; p.20 top; p.42 top; p.78 top; p.116 bottom. Associated Newspapers: p.20 bottom. Yorkshire Post Newspapers: p.21; p.22; p.23 top; p.31 bottom; p.100 bottom; p.110 top, p.122; p.123; p.124 top. West Yorkshire Archive Service, Leeds: p.28 bottom; p.49 top; p.119 top. Leeds Museums and Galleries: p.46 top; p.59 bottom; p.60. Leeds Civic Trust: p.48 bottom; p.57 top; p.80 top; p.91.

The Leodis website has received funding from the New Opportunities Fund (now the Big Lottery) and is managed by Leeds Library and Information Service.

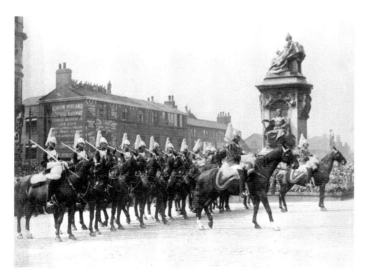

King George V and Queen Mary opened the Civic Hall on 23 August 1933. This photograph shows Life Guards, who formed their escort, in Victoria Square. In the background the statue of Queen Victoria can be seen; this was later relocated to Woodhouse Moor

Introduction

This book has been produced as a direct result of the popularity of the Leodis website. The images you see in this book are just a small number of the thousands of Leeds photographs available through the website.

Leodis is an online photographic archive containing over 45,000 images of Leeds old and new. The site was initially set up by the Leeds City Council Internet team as a way of making accessible some of the photographs in the collections in Leeds Local Studies Library. This proved immensely popular and in 2001 Leeds Library and Information Service secured a grant from the New Opportunities Fund to develop the site and digitise a large proportion of our photographic collections. During the project Leeds Library and Information Service worked in partnership with Leeds Museums and Galleries, the Thoresby Society, Leeds Civic Trust and West Yorkshire Archives Service. Collections from each of the partners have been added to the site making it a huge resource.

Before the site was set up many of the photographs were relatively inaccessible to the public. Visitors would have to travel to the Local Studies Library and look through the catalogue to find photographs they wanted to view and then original images had to be brought out. Having the photographs on the website has proved very valuable in terms of preserving the original photographs from damage. Some of our collections were also held at various points around the city in our branch libraries so would require further visits to different locations for people wanting to view photographs from different areas in Leeds. Through Leodis these photographs are now available together for the first time. During the course of the project many photographs were catalogued and added to the site which had never been available before.

The largest collection of photographs held in the Local Studies Library is the City Engineers collection. These provide a unique record of changes to the city between 1890 and 1960 as the City Engineers photographed all potential alterations to property and roads as well as events in the city. These images include photographs of the slum clearance of areas deemed 'unhealthy' in the early twentieth century and road alterations, and by their very nature allow us to view areas of Leeds which now have changed beyond all recognition. The original City Engineers collection was split between Libraries and Archives and as a result of this project we have been able to digitally reunite the collection. West Yorkshire Archives Service have made available their City Engineers' photographs, predominantly from the 1950s and 1960s, of the housing clearance programme at this time and these can now be viewed on the site.

The City Engineers' photographs were taken by the official surveyor working within the City Engineers' department and were the working tools used by the men to carry out jobs such as street improvements, demolition of buildings and road repairs. They often feature several of the workmen standing to one side waiting for the photographer to finish his work, and sometimes one will be holding a large measuring pole against the side of a building, so that the size and scale can be gauged. One of the most interesting aspects of the very early photographs is when a small group of children are caught on camera, the girls wearing pinafores over their dresses, and the boys in knickerbockers and caps. One can imagine them

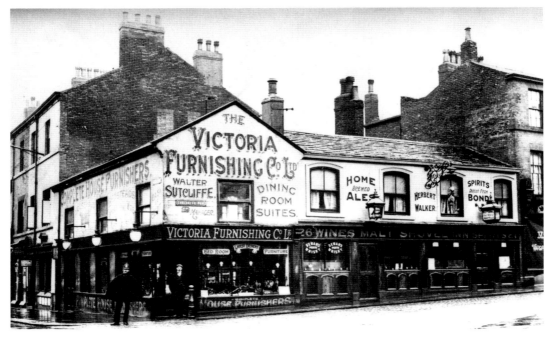

The Lowerhead Row in 1907 at the junction with Vicar Lane. The Victoria Furnishing Co. can be seen as well as the Malt Shovel Inn.

seeing the man with his tripod and black cloth over his head and clamouring for him to take their photograph! This is what makes the collection an important social record of Leeds, as well as showing us what our city once looked like and how much it has changed.

Other collections of photographs available include a postcard collection, Leeds School Board photographs, a transport collection of Leeds buses and trams, and a collection of photographs of churches. Within the collections in the Local Studies Library we also have photographs from individuals and companies who have donated their images to the library in the past and have been generous in allowing us to make them available through the website. The partners' collections have also proved invaluable and have helped add greater depth and diversity to the site. These include images from the Photopress collection at West Yorkshire Archive Service, as well as a huge collection of images of Kirkstall Abbey from Leeds Museums. Leeds Civic Trust and the Thoresby Society have both made available valuable images not previously accessible before, including the Lupton mayoralty album from Hugh Lupton's time in office as Mayor in the mid-1920s.

Leodis now has visitors and hits from around the world. One of the special facilities on the site is the fact that users can add their own comments to the photographs and share their memories of life in Leeds. These comments have proved an invaluable way of preserving the history of the city and also allow users to interact with each other.

To complement the main photographic archive Leodis has also made available thousands of playbills from the old Leeds theatres and provided greater detail on a variety of topics of historical interest for Leeds. These topics, on our sub site Discovering Leeds, include information for example on the old Leeds theatres and the development of the Headrow.

If you wish to see more images of Leeds visit www.leodis.net to view thousands of photographs and take a trip down memory lane.

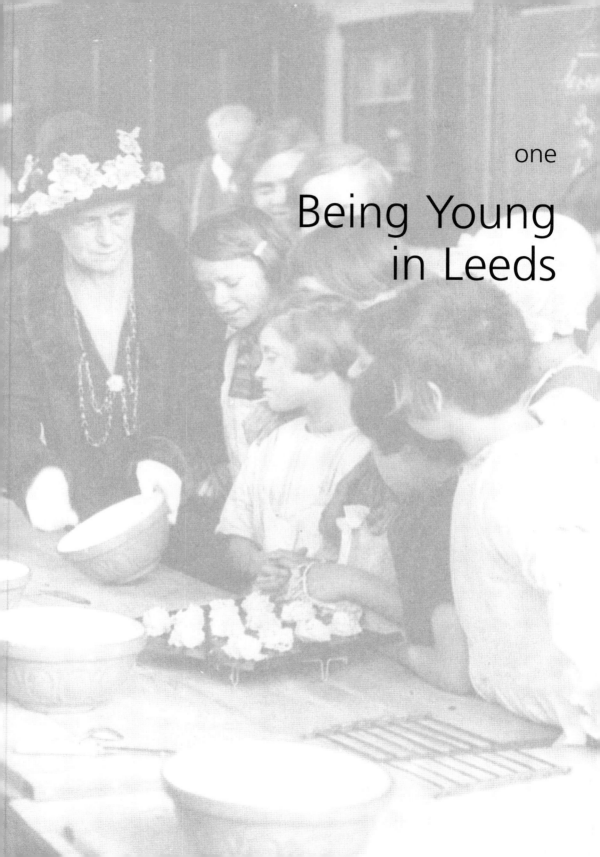

one

Being Young
in Leeds

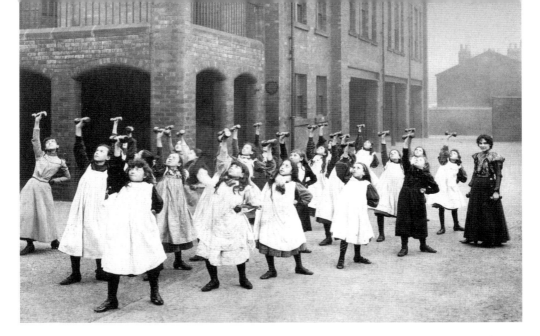

Darley Street Board School was opened on 7 January 1895. The first headmaster was Mr John Graham Wood. His wife, Sarah Annie Wood, was the headmistress of the infants' school. The little girls here are having a drill lesson in the school playground. Each girl holds a weight in her hand, and rhythmic movements were made at the command of the teacher. This series of photographs comes from a volume of Leeds School Board photographs from around 1902.

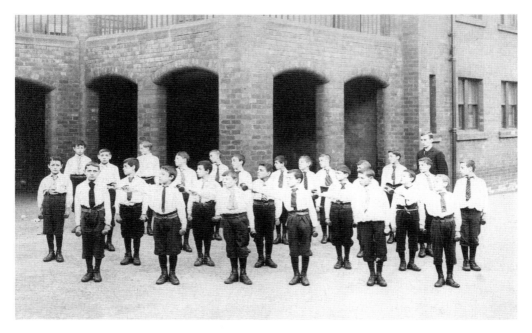

Boys and girls were, of course, segregated at this time. Drill lessons were the pre-cursor to PE, and the boys' exercises differed only slightly from the girls'. Weights were held in each hand, and the movements were made in the manner of a regimental drill. Note the 'snake' belts that some of the boys are wearing.

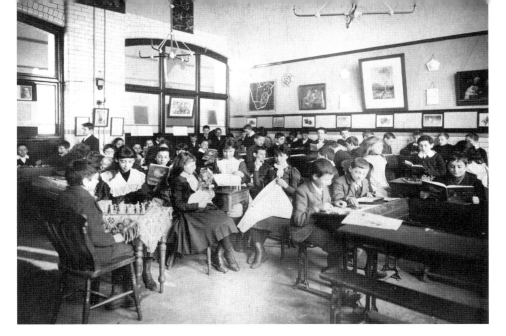

Here we see the Hobby Club, in which children were encouraged to pursue improving hobbies, such as chess, reading and sewing. A little girl in the middle of the picture can be seen nursing a doll, so perhaps motherhood was seen as an improving hobby! Although posing for a photograph the children appear to be remarkably quiet and well-behaved – discipline was also considered an important aspect of schooling.

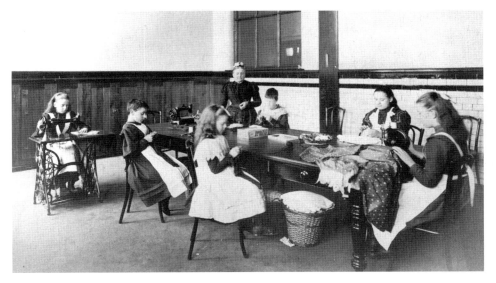

The exact location for this photograph is uncertain, but it could well be the Home and School for Deaf and Blind Children in Blenheim Walk, which was officially opened on 5 July 1899. According to the official handbook published for the occasion, Mr G. J. Cockburn, Chairman of the Leeds School Board, took a party of Leeds worthies on a guided tour of the school, during which they were treated to songs sung by some of the blind children, followed by demonstrations of lip-reading, mental and written arithmetic, paper mounting designs and Indian club and wand drills.

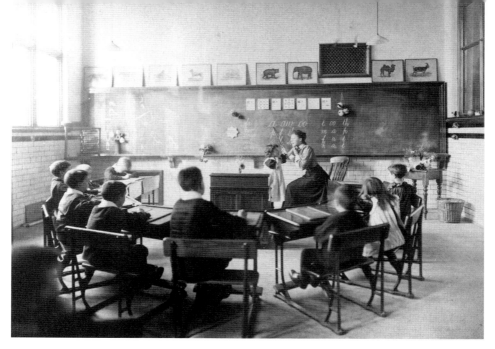

An undated photograph of Leeds School for Deaf and Dumb Children, Blenheim Walk. The children are learning how to speak. The teacher is sitting with a child, who has one hand on the teacher's throat, the other on her own. As the teacher articulated sounds, the child learned to recognise the varied throat movements.

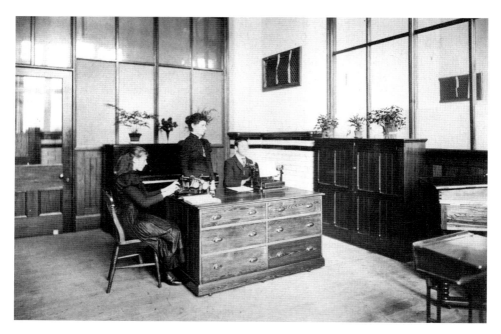

Another image from the Leeds School for Deaf and Dumb Children. It was recognised even then that these children would eventually have to make their own way in the world and typing was one of the skills they were taught to enable them to do this.

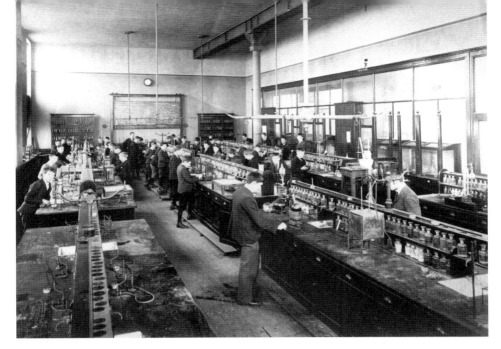

An undated photograph of a chemistry lab in Leeds Central Higher Grade School, Woodhouse Lane. Boys are working at the benches, which have an impressive array of equipment.

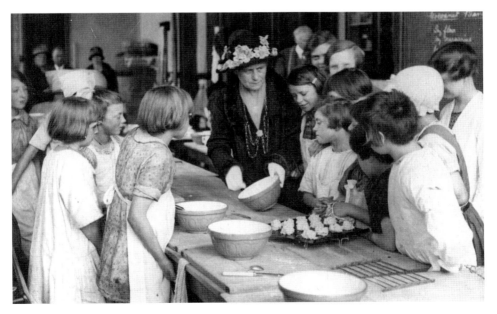

The Lady Mayoress, Ella Lupton, observes a lesson in cookery at Blenheim Council School on 28 July 1927. Coconut buns were being made and the recipe was chalked up on the blackboard for the children to follow. Blenheim School, at the time of this visit, was being used as a 'Holiday School', a sort of forerunner of today's after-school clubs. For three weeks during the summer vacation, provision was made for local children who had nowhere else to go – the alternative was playing in the streets.

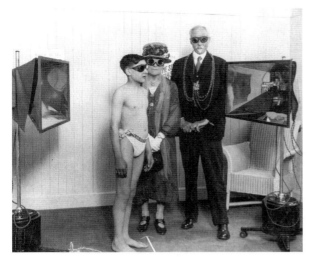

A young boy demonstrates the benefit of the Alpine Sun Baths, which were in the City Baths in Cookridge Street. These were designed by Cuthbert Brodrick and were also known as the Oriental and General Baths. The boy is wearing the regulation Leeds City Council bathing trunks and protective eye goggles. Therapeutic sunbathing, or 'Sun Cure', was widely prescribed as a medical treatment for such diverse ailments as rickets, cholera, tuberculosis, viral pneumonia, asthma, gout, jaundice and even severe wounds. The Lord and Lady Mayoress, Alderman Hugh and Ella Lupton, are also in the photograph and wearing protective goggles too.

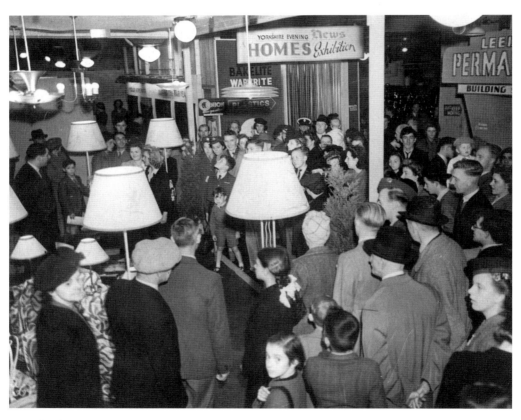

Crowds of Leeds folk wander around the 1945 Homes Exhibition, sponsored by the *Yorkshire Evening News*, and held in Lewis's Department Store. This was probably regarded as an exciting day out for all the family, judging by the number of children being dragged round by their parents! VE Day had been celebrated only a few months previously, on 8 May, and the population was doubtless ready for some light relief and an end to the austerity of the war years.

A matinee luncheon held in honour of the 'Boots for the Bairns' charity, February 1927. The charity was a joint initiative launched by the *Yorkshire Evening Post* and the Education Department in 1921. There was desperate poverty amongst some of the Leeds population at that time and the better-off folk dug deep into their pockets to help their fellow citizens. Over £60,500 was donated between 1921 and 1930, which provided over 80,500 pairs of boots, 78,500 pairs of stockings, and 184 articles of other clothing. Every pair of boots was produced using local labour and local materials.

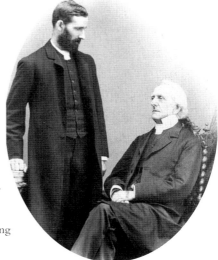

On the left is Canon David Allison, with Canon Edward Jackson on the right. These two men shared the living of St James church, York Road, Leeds. Canon Jackson was regarded as something of a saint in Leeds. Amongst many other acts of kindness and charity, he provided free dinners for the poorest scholars of St James church school. Although there was no stipend attached to the parish, Jackson repeatedly refused the offers of other livings, including that of Bolton Abbey, preferring to stay in the poverty-stricken slums and help his flock. At his funeral, it was said that almost the whole of Leeds turned out, including some 1,500 children. On his death in 1892, Canon Allison succeeded him.

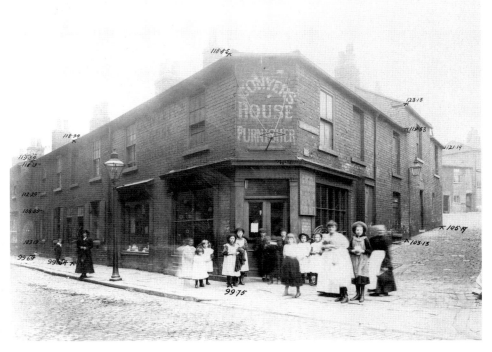

Many of the photographs in the collections of the Leeds Local Studies Library come from the working photographs of the Leeds City Engineers Department, which was responsible for such things as road repairs, slum clearance and general street improvements. A man with a camera and tripod was a bit of a novelty at the turn of the century so local children would gather together on street corners to have their photograph taken. This photograph was taken in 1903 in Rookes Fold, off East Street, near the city centre.

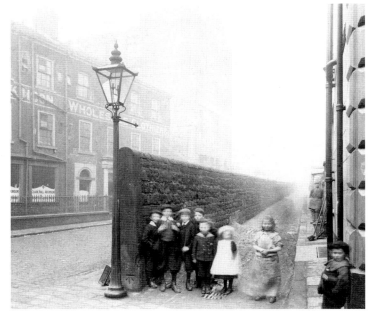

More street urchins have gathered here for their photograph to be taken, this time in Chorley Lane, March 1904. They are standing in the lee of an old stone wall which ran along the front of Bedford Row. At the end of the Row was the Bedford Hotel, a small portion of which can be seen at the right of the photograph. On the opposite side of the road is the clothing factory of Clark, Hall & Atkinson.

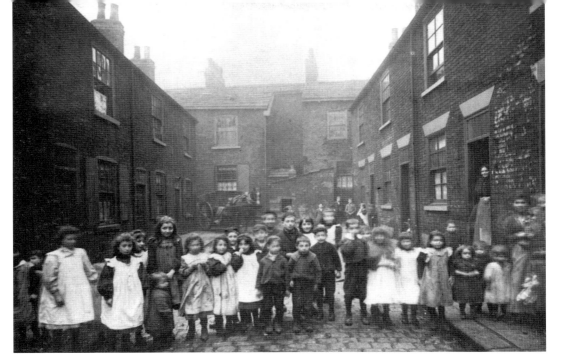

The Leylands area of Leeds was one of considerable poverty in 1901, the time that this photograph was taken. The area was home to many Jewish and Eastern European refugees, and housing conditions were cramped and overcrowded. Bell Street, seen here, was part of the Leeds Unhealthy Areas programme and destined to be demolished in the city's slum clearance project. In the census of 1901 Bell Street had some twenty-nine houses, in which nearly 100 children under fifteen were living with their families. Here, about a quarter of them are gathered for the photographer.

The Leeds Methodist Mission did a lot of work amongst the poor and needy in the slums of Leeds, especially with women and children. The introduction to the 1910 annual report of the Mission says: 'It is very dark outside. We are working in the most criminal quarters of Leeds, and the poorest. And as we work the darkness is making itself felt in the hearts of the people; they are longing for something better, and they come to us to show them the way.' They also came for something a bit more substantial, and in 1910, when this photograph was taken, the Mission workers distributed not only religious tracts but Christmas parcels of coal, food and clothing.

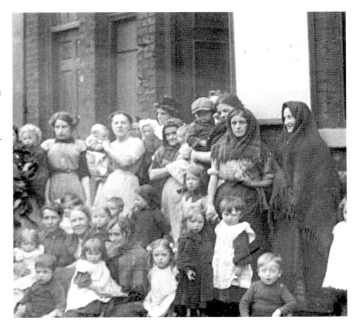

The exact date and location of this photograph is unknown, but the women and children seen here are recipients of help and support from the Leeds Methodist Mission, based in Oxford Place chapel, next door to Leeds Town Hall. Methodist ministers preached against the evils of drink and immorality, but would also offer food, clothing, education for the children, and other practical help.

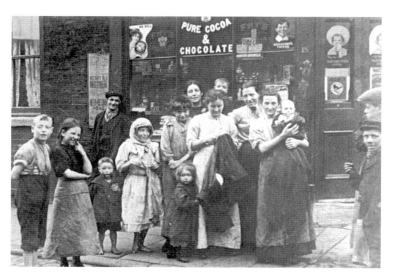

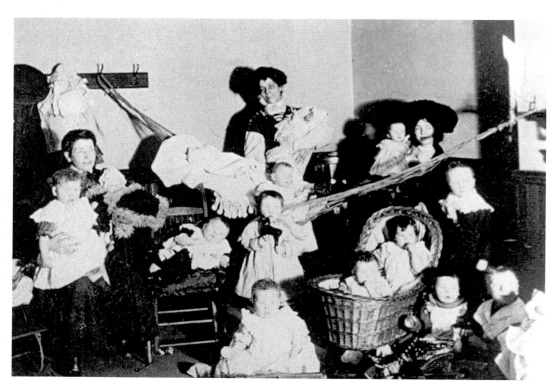

The Oxford Place nursery, 1909. The children here look happy, healthy and clean. The Mission workers were extremely concerned about the welfare of the poor women and children of the area, many of whom suffered greatly at the hands of drunk and violent husbands. The annual reports of the Leeds Methodist Mission are filled with heart-warming stories of little children who were helped by the Mission workers and who occasionally even managed to get their parents to attend services and give up the demon drink.

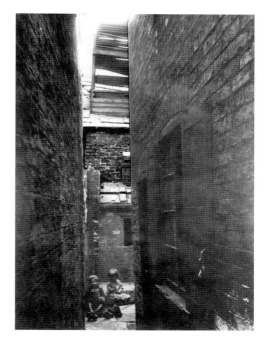

Right: Three tiny and ragged-looking children sit on the stone flags of one of the many yards that used to lead off Kirkgate. This particular yard was to the north of the Old Nag's Head and could be either Croisdale Court or Cherry Tree Yard. The photograph is from 1901, and Kirkgate was at that time a warren of similar courts and yards, every one overcrowded and unhealthy.

Below: Hirst Square was one of the many 'unhealthy areas' to be cleared in the early 1930s. The courts and yards in this area were cleared to make way for the building of the new Civic Hall and Leeds General Infirmary. This photograph dates from 1930. Although Hirst Square was designated a slum it looks relatively clean in this photograph and the children do at least have an open area to play in. There is a home-made four-wheel buggy by the steps in the middle and the little boy on the left of the picture has a shovel almost as big as himself.

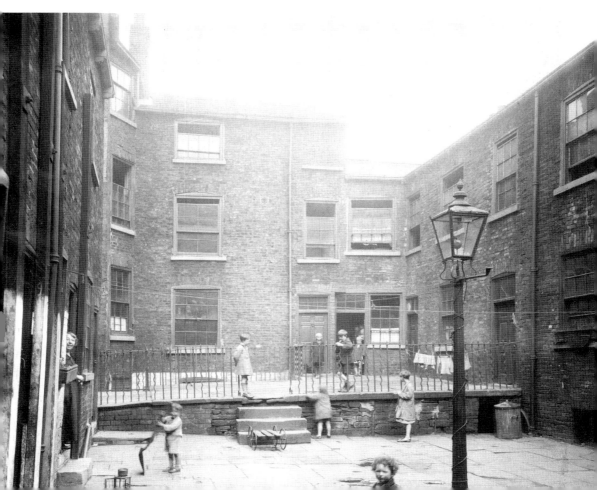

The Lord and Lady Mayoress of Leeds, Hugh and Ella Lupton, entertain children from the council schools of north Leeds in January 1927. It is recorded that 1,055 children attended this event. Treats included Christmas crackers, three huge illuminated Christmas trees and entertainment from pantomime artists at the Grand Theatre. No doubt the jelly and ice cream flowed as well! At the end of the day the exhausted children were ferried home by special tramcars.

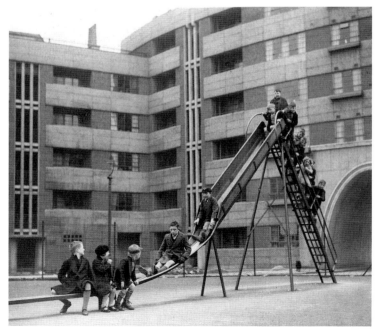

The famous Quarry Hill Flats were built to replace the slums that had been demolished by the council. They were hailed as a marvel of modern living – clean, self-contained, light and airy, a far cry from the overcrowded terraces that once filled the area. This photograph shows one of the three playgrounds within the Quarry Hill flats complex. This was the Kitson House playground. The other two were at Thoresby House and Moynihan House.

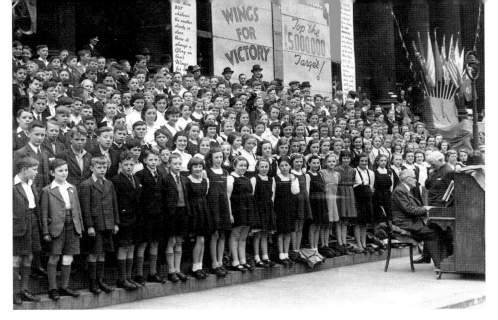

The Wings for Victory campaign in Leeds ran for a week from 26 June and was one of many such campaigns held all over the country to raise money for the war effort. In Leeds, each day of the campaign had a different focus, and 30 June was dedicated to the children of Leeds. Here, a choir of 250 schoolchildren stand on the steps of Leeds Town Hall. The indicator at the back shows how much money had been raised and was moved up by four children who we just know as Jean, Doris, Colin and Maurice. A total of £7.2 million had been raised by the end of the week.

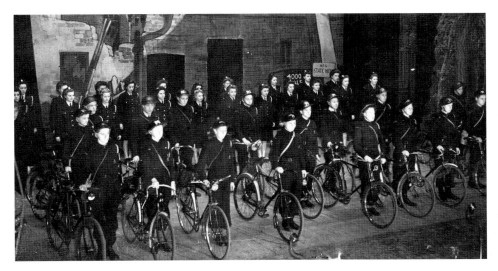

The first 'Youth Marches On' event was staged at the Grand Theatre and ran from 20-25 September 1943. It was funded and promoted by the *Yorkshire Evening News*, who described it as a 'Great Cavalcade ... portraying the spirit of our youth today'. The show played to packed audiences every night, and the YEN's daily reports described it as 'a virile and exciting festival'. In this scene, we see the Leeds Messengers, young people who were employed during the war, moving between first aid and air warden posts. The show was a tribute to youth, designed to show that the future lay on the shoulders of the young.

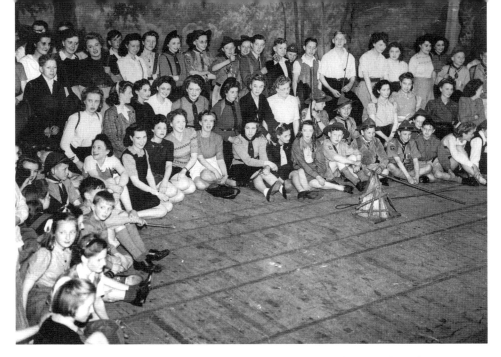

The second Youth Marches On event was again held in the Grand Theatre, and ran from 4-9 June 1945, presumably to celebrate the end of the Second World War. Here we see a campfire scene from the event.

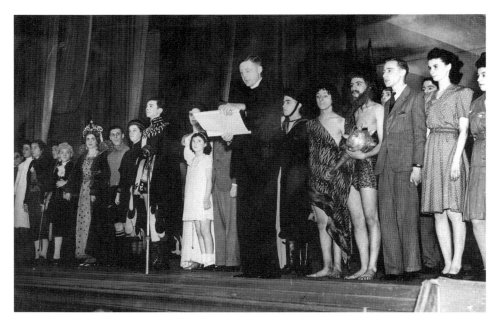

In this photograph, the Vicar of Leeds, Canon A.S. Reeve, gives the closing speech on the last night of the show. One of the sketches involved the cast members dressing up as famous historical figures and on the far left is Reg Blackshaw from Wortley, dressed as Mozart in a white wig. Reg had earlier performed a violin solo to great acclaim during this part of the show.

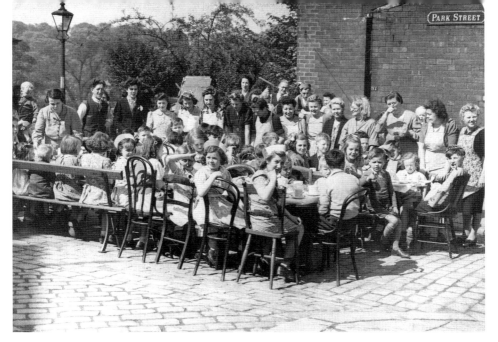

One of many street parties held in Leeds to celebrate Japan's surrender and the end of the war. This took place in Park Street, Leeds for which people had dragged out all their furniture to form a makeshift banqueting table. Although food was still rationed, the population would have pooled their ration books together to provide a feast. In the background a bonfire is ready for lighting.

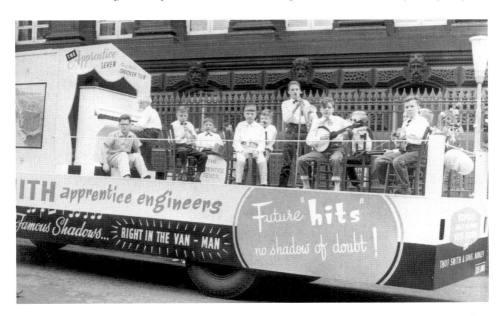

Children's Day in Roundhay Park had been a feature of Leeds since 1922. Leeds headmaster Archie Gordon of Lower Wortley County Primary School wanted to improve the lives of Leeds children, especially those in the poorer areas, and organised a day out in the park with fancy dress, bonny baby competitions and other jolly activities. The idea took root and flourished until the 1960s. In this photograph, taken on 14 July 1962, the Roundhay School rock band pose as The Shadows.

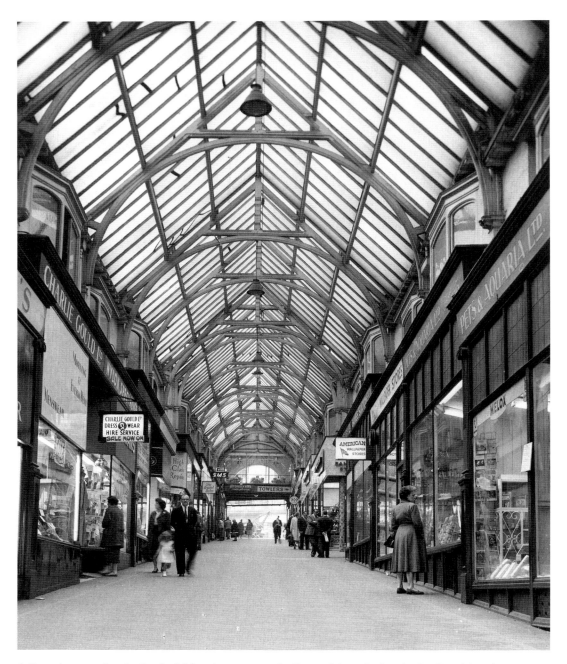

A favourite attraction for Leeds children in town was the Pets and Aquaria shop in the Grand Arcade. Established in 1938 by amateur zoologist Arthur Snow, the shop had a corner window featuring the latest litters of kittens and puppies for children (and mums, no doubt!) to coo over. A less well-known fact is that for many years Mr Snow ran his own Leeds Zoo upstairs, which customers could visit. This was a private menagerie with porcupines, small apes, baboons, reptiles, fish and even a small bear. When the Queen was crowned in 1953, son-in-law Bill Birch imported hundreds of red, white and blue 'coronation fish', or neons, which he sold for the equivalent of £1.50 each.

two

Housing

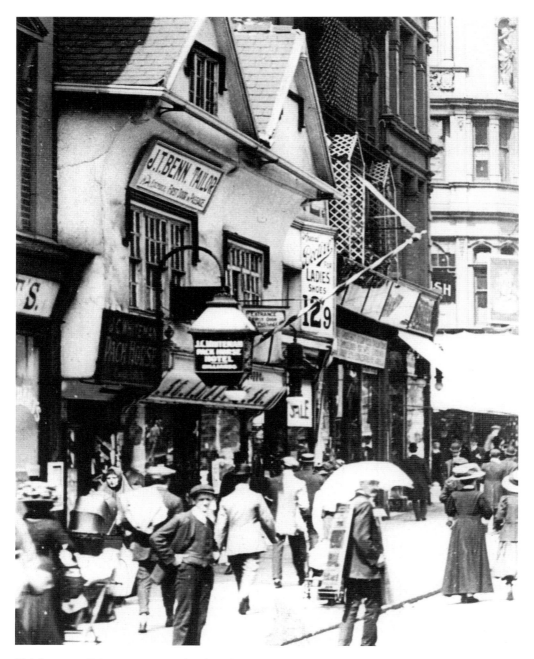

This house on Briggate was reputed to have been one of the oldest surviving buildings in Leeds when this photograph was taken in 1909. It was a timber-framed house built in 1615 for wealthy merchant Richard Sykes and located at No. 56 Briggate next to Pack Horse Yard. Signs for the Pack Horse Hotel can be seen. In 1629 Richard Sykes, then Lord Mayor, had negotiated the purchase of the manor of Leeds from the London Corporation who at that time owned it; he then became one of the leading members of the newly established Leeds Corporation. The building was demolished in 1955 for an extension to Timpson's shoe shop which had taken over the site.

Several merchants' houses were built in the centre of Leeds. These included Red Hall on Guildford Street, believed to be the first red-brick building in Leeds, built in 1628 for Alderman Thomas Metcalfe. The garden became King Charles Croft, eventually becoming home to the Tivoli and Theatre Royal in the 1800s. During the Civil War King Charles I was held in captivity at Red Hall and the room used was then known as the Kings Chamber. In 1912 it was taken over by Snowden Schofield and the Kings Chamber became the Old English Café. The building was demolished in 1961 and the Headrow Shopping Centre is now on the site.

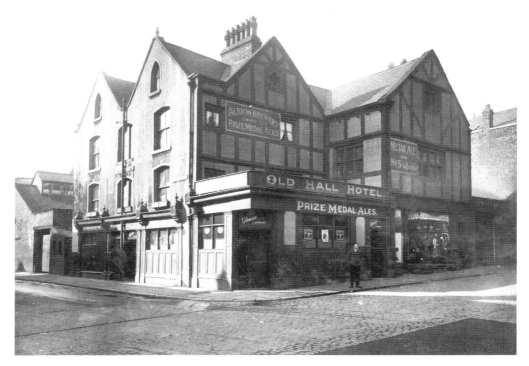

Wade Hall was built between 1630–40 for Thomas Jackson and named after benefactor Thomas Wade. A large part of the hall was demolished in 1863 to build Kelsall Street from Woodhouse Lane to Wade Lane. The remaining part became the Old Hall Hotel before it was demolished for the building of the Merrion Centre which officially opened in 1964. Mrs Mary Smith was landlady until shortly before it was compulsorily purchased by the council in 1937. After demolition the site was used as a car park before the Merrion Centre was built. The Old Hall Hotel reputedly had two sealed doorways in the cellar, alleged passageways to Kirkstall Abbey and to St John's church.

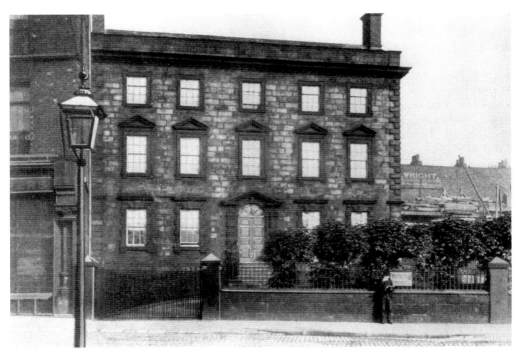

Bischoff House was built in 1692 for Nathaniel Denison by William Etty. It was originally called Sheepscar Hall but renamed Bischoff House after it was purchased by Bernard Bischoff who came from Basle in around 1715. He was a wealthy wool merchant and became a prominent citizen of Leeds. With four sons, he founded a prosperous dynasty. The house stood at the junction of Hartley Hill and North Street and was demolished in 1968. The site is now the car park for Centenary House.

Sheepshanks House was a merchant's house of the early eighteenth century. It was designed and built for Robert Denison, a cloth merchant, and was originally recorded as 10 Town End but was later addressed as 42 North Street. It later came into possession of the Sheepshanks family of woollen merchants. The site of the house eventually became that of the Ritz cinema which opened in 1934, later to become the ABC cinema. Many merchants of the time lived in premises adjacent to their businesses and the Sheepshanks were no exception. Sheepshanks Yard, adjacent to the house, survived until 1967 and was used by a variety of businesses.

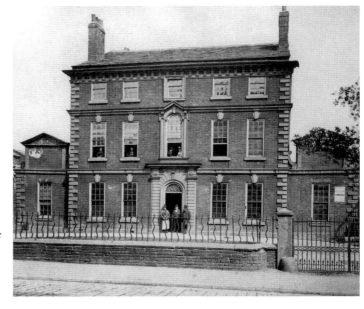

Denison Hall was designed by William Lindley for John Denison. Formerly John Wilkinson, he changed his name to Denison on inheriting the fortune of his uncle Robert Denison on his death in 1785. The house was built in 1786 on land purchased for £8,500 but John Denison only lived here a short time as on his marriage in 1787 he moved to Ossington Hall. In 1796 it was leased to Sir Richard van Bempe Johnstone and later in 1806 Harry Wormald became the

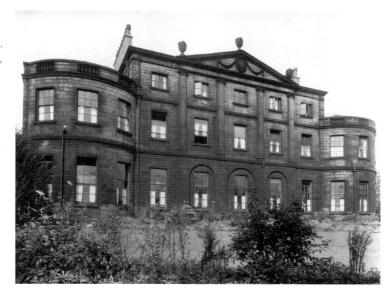

owner. George Rawson next developed the estate in 1824. The hall was divided into two residences but remained in single ownership until it was sold in 1912 by Edmund Wilson who had lived in the western half of the house. By 1917 Denison Hall had become a nursing home and in 1962 an old peoples' home. After 1989 it was empty for some years but has now been converted into apartments.

From the 1780s the Park Estate grew up at the west end of the town away from the town centre and busy highways, but near to the Coloured Cloth Hall. Many merchants moved here at the time but kept their business premises in town. The terraces and squares of the Park Estate were secluded and genteel. Park Square was developed first on the east side then on the west and northwest sides. Architects of the buildings included John Cordingley and Thomas Johnson. Their appeal as residential

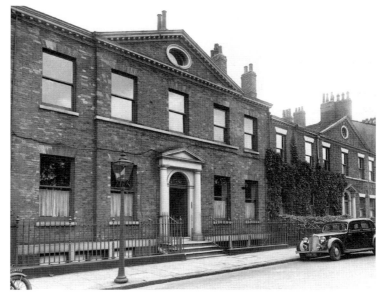

homes was lost when industry began to encroach around the square, in particular, Benjamin Gott's Bean Ing Mill. Many in the medical and the legal profession later used the houses as offices. This view shows Park Square in 1948.

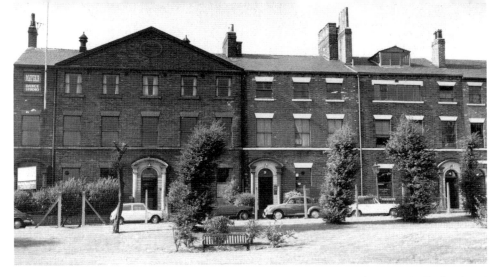

The other Georgian square to survive intact in Leeds is Queen Square. This was initially developed by John and George Bischoff, brothers who had lived at nearby Claypit House since 1787 and owned the adjacent land. The square was planned as three terraces round a central garden, with the fourth side left open to Claypit Lane. In 1822 the residents of the square purchased the central area of land to provide a permanent garden. Buildings in the square have now been refurbished and are used by Leeds Metropolitan University.

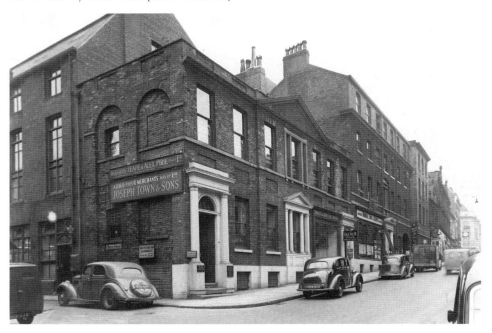

An undated view of Nos 1 and 1A Albion Place. This was the house of Dr William Hey and was built between 1794 and 1795. He was twice Mayor of Leeds and was founder of the first Leeds Infirmary in Infirmary Street which replaced the temporary one he had set up at his former home in Kirkgate in 1767. The new infirmary received its first patient in 1771 and Hey became senior surgeon two years later. He was instrumental in setting up the Medical Society in 1768 and in 1783 became president of the newly formed Philosophical and Literary Society in Leeds.

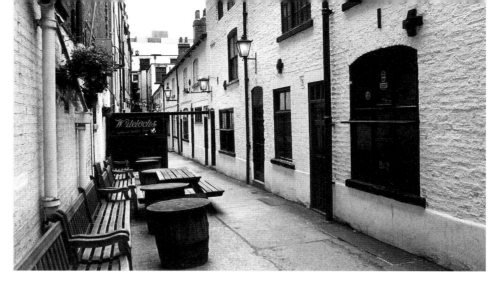

Many of the poor in eighteenth-century Leeds lived in the yards and courts off the main streets. Workers cottages can be seen in Turk's Head Yard, opposite Whitelock's Inn. This long and narrow yard was once a burgage plot, a piece of land held by burgesses or free men of the borough. Thirty of these building plots and gardens could be found on each side of Briggate. This one is now a city centre beer garden.

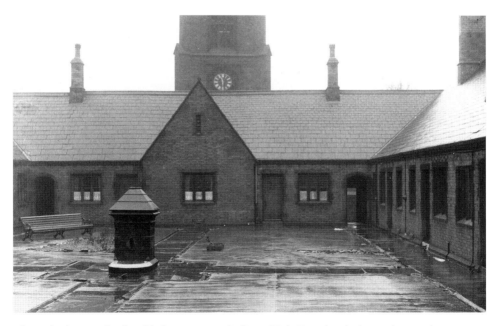

These almshouses, for the elderly poor, were built on Wade Lane by cloth merchant and benefactor John Harrison in 1653. He also built St John's church (1631-1634) and rebuilt the Grammar School on North Street. He built a pair of almshouses each with twenty apartments for poor women each endowed with a yearly income of £80 to provide a pension and the means to maintain the houses. Harrison was born in Leeds in 1579 and was a member of the Committee for Pious Uses established in 1619 to oversee the town's charities. This view was taken shortly before demolition in the early 1960s.

The old workhouse in Vicar Lane seen shortly before demolition in 1936 to create space for the bus station. Built in 1629, it opened and closed several times over the next hundred years before being enlarged and reopened in 1736. The Vestry of Leeds parish church acted as the Workhouse Board and decided who would be admitted. In 1797 Sir Fredrick Morton Eden reported, 'There are 154 inmates in the Workhouse, of whom 42 are old and infirm men or lunatics, 56 women, many of them soldiers' wives, and 56 children, mostly

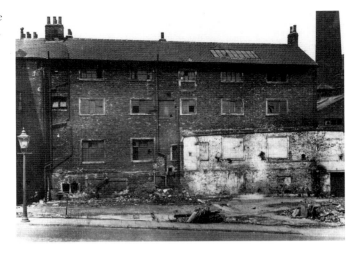

under 12. There are a few cripples or idiots between 12 and 20. The Workhouse is an old building, in the town, with accommodation for 200 persons.'

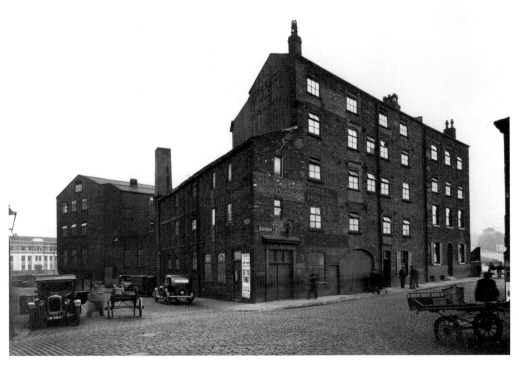

Leeds Model Lodging House at the junction of Dyer Street and Millgarth Street in 1934. In 1872 there were 129 such lodging houses with 1,502 lodgers between them. Great efforts were made to regulate lodgings and provide better facilities. Model House had been a dye works but was converted and regulated to provide clean beds, food and washing facilities for men. In the inter-war years, when men moved round the country looking for work, it was a very necessary provision. The manager in 1934 was Francis Bott. When this lodging house closed, it was replaced by a new building, Shaftesbury House in Beeston.

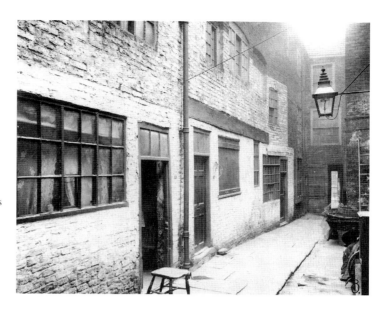

Right: In the nineteenth century wealthier families were gradually moving further out of town while workers' housing was being built in the yards and courts, and then back-to-back housing on the edge of the city centre. This is Camden Court, off the Lower Headrow, showing workers' houses with a yard and access out on to the main street. This photograph was taken on 30 April 1924 by the city engineers' recording examples of the unhealthier areas of the city.

Below: Photograph taken on 30 September 1913 looking along Back Portland Crescent near the junction with St James Place. This area housed workers in terraced housing rather than in the yards and courts. This area was demolished for the building of the Civic Hall which opened in 1933.

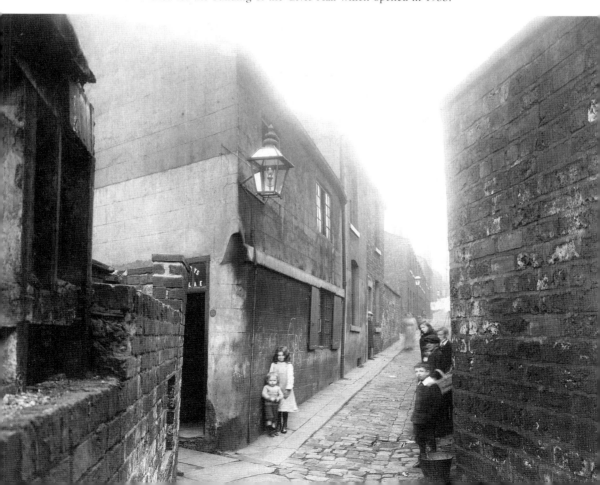

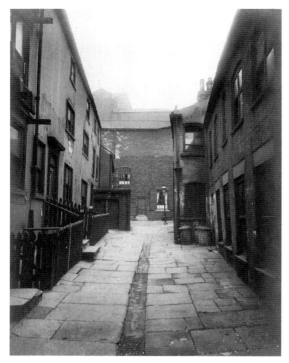

Maltmill Yard off the Lower Headrow, photographed by the city engineers on 10 October 1928 just prior to demolition. In 1924 a scheme was approved to widen the Headrow to create a new east-west thoroughfare through the city. All property on the north side of the street had to be demolished to widen the street. The Leeds Corporation Act of 1925 gave compulsory powers of purchase on these properties. No. 7 Malt Mill Yard, straight ahead at the far end of the yard was, in the early 1900s, home to Rosa Annie Dalton and her four children. After the death of her husband in 1900 she continued the family business as a wireworker, making dartboards from home.

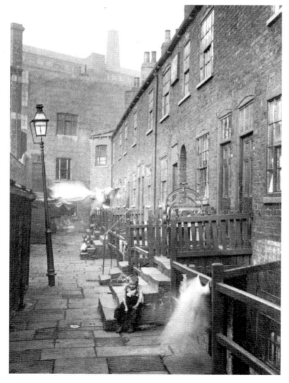

Sykes Yard, off York Street, 1901. Census returns for 1851 indicate the overcrowding in these yards. At No. 10 the residents were: Thomas Vasey, labourer (28), Jane Vasey, spinner (20) and son John (1). Jane's sisters and brother (18, 9 and 4) lived with them and a lodger, Michael Burke. In the 'upper room' lived John Mannix, commercial traveller (40), his wife Rose Ann, cordwainer (45), his sister Cecilia, spinner. They had two lodgers; Harry Chapman, shoemaker (36) and William Riley, tailor (32). In the cellar lived William Mitchell, shoemaker (42), Harriet his wife and James Tindale, lodger (9). In a second cellar lived Solomon Autey, general dealer (39), his wife Elizabeth, their sons William (10), Thomas (7) and daughter Mary Jane (4).

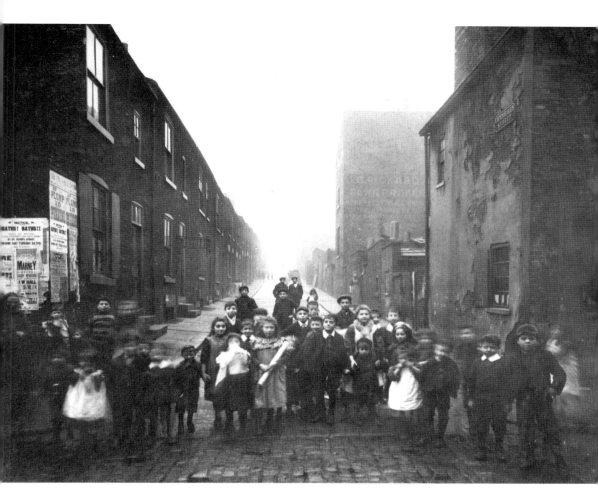

The Leylands area just outside the city centre to the north also gives a good view of how people were living at the turn of the last century. Many of these areas had been classed as 'unhealthy areas' by the city engineers. This is Copenhagen Street from Bridge Street in 1901. At the other end of the street was North Street. A large number of Jewish immigrants had settled in this area – several of the posters on the wall to the left are in Hebrew. Overcrowding and poor sanitation led to the demolition of much of the housing in this area a few years after this photograph was taken. Copenhagen, Nile and Trafalgar Streets were reputed to have been built by the Bischoff family to commemorate Nelson's victory at Trafalgar in 1805.

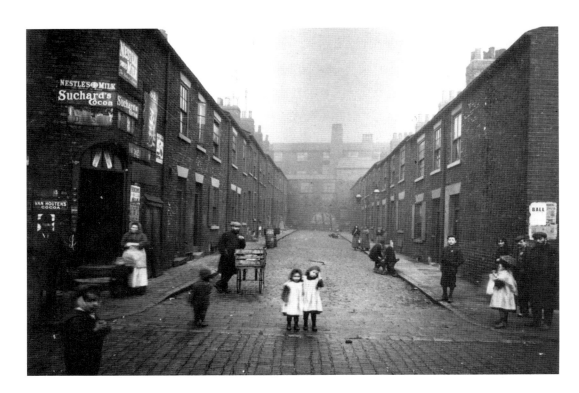

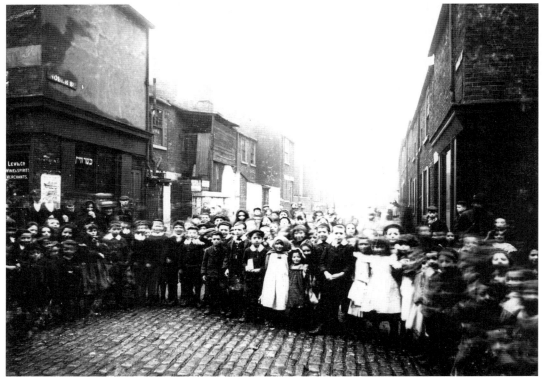

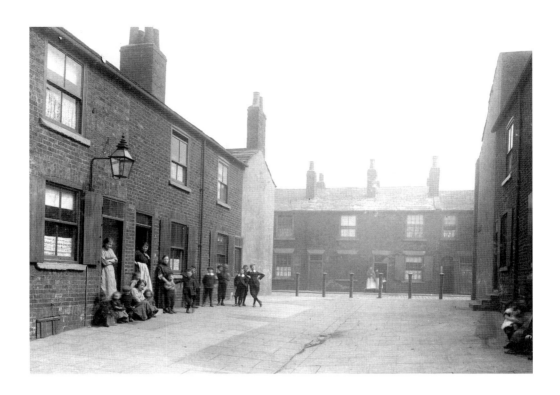

Above: Charles Place, formerly 2-6 Marshall's Court, in 1908. Situated between Shear Street and Billet Street, these two-storey brick houses were part of the Quarry Hill area of 'unhealthy' housing.

Right: Clarkson's Yard, off Quarry Hill, looking west. This narrow yard was listed for demolition in 1901.

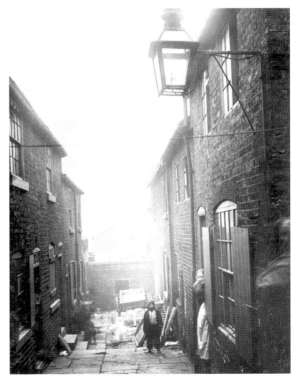

Opposite above: Cross Templar Street on the edge of the city centre and Leylands, looking from Templar Street, in 1901. This was part of the Leeds Unhealthy Areas improvement scheme.

Opposite below: A crowd of children stand at the junction of Noble Street (centre) and Hope Street. On the left are the premises of Levi & Co., wine and spirit merchants.

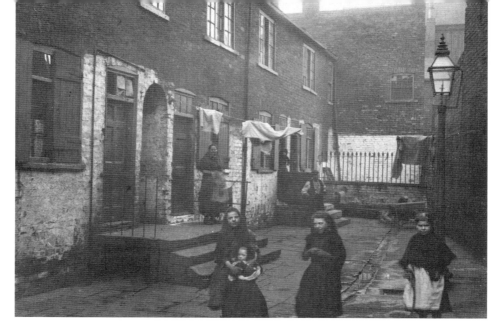

Quarry Hill, on the edge of the city centre, is thought to have been one of the oldest inhabited parts of Leeds. In the late 1700s much housing was built in this area. By the mid-eighteenth century it was classed as an unhealthy area, with infected water leading to outbreaks of disease. There were numerous wells in the area which frequently became polluted and many houses had no toilet facilities other than a bucket emptied into a common midden. This is Dufton's Yard off Somerset Street which was near St Peter's Square, in 1901.

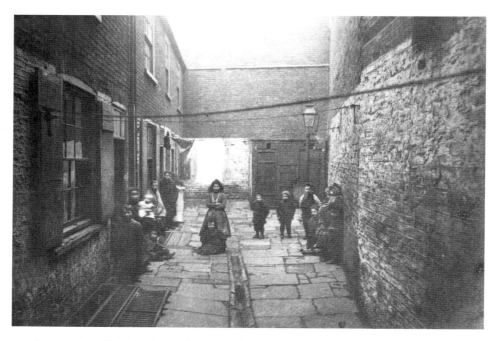

Another example of housing in the Quarry Hill area of the city. Children are posing for the photograph in Pounder's Court which was off St Peter's Street.

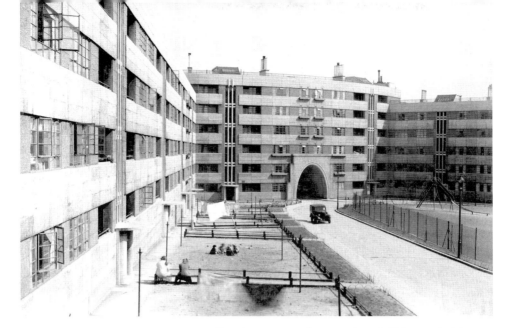

Clearing unhealthy housing in Quarry Hill took many years; by 1914 about half the area had been cleared. Director of Housing R.A.H. Livett and the Revd Charles Jenkinson visited Europe for inspiration in new housing. They were impressed by workers' flats in the Karl Marx building in Vienna which became the model for Quarry Hill. The 23-acre site was to have 938 flats, in a range of sizes, a central laundry, shops, a community hall and courtyards with playgrounds. The proposed tennis courts and bowling greens were never built. This photograph, taken in 1939, shows Lupton House, on the left. The first occupants, in March 1938, were Mrs Conway and her three children at No. 34. In the centre, with the entrance archway, is Kitson House.

An early view of Quarry Hill flats in 1939. A woman outside Lupton House hangs out washing on lines strung across the as yet undeveloped garden plots These flats were seen as a model housing scheme and became internationally famous, although there were problems with the experimental building systems used which resulted in costly on-going repairs.

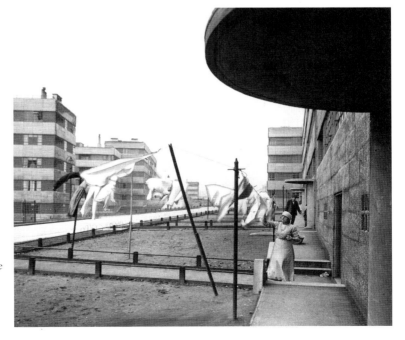

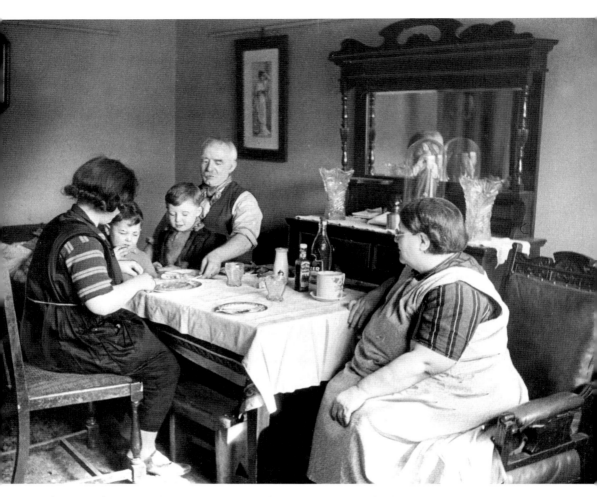

This 1939 photograph shows the interior of a flat, with the Holmes family seated around the dinner table in the living room of their flat in Lupton House. Living rooms in Quarry Hill had been designed to include both sitting room and dining room areas.

Opposite: A lady demonstrates the use of the Garchey waste disposal unit in the sink in 1943. This system was a revolutionary French device for disposing of kitchen waste directly to a central incinerator with the heat generated used as a power source. The large cover on left has been removed from the disposal shaft and she is tipping a shovel of ashes from a coal fire. On the wall, under the shelf of crockery, a notice gives instructions: 'Do Use It for Ashes, all small tins, and refuse that will pass the gauge. Don't Use It for Large or Long articles, rags etc.' A separate building on the estate was provided for these. Unfortunately there were problems – the waste stacks leaked and the hoppers under the sink were smelly. The failure of the system was one of the main reasons the flats were demolished forty years later.

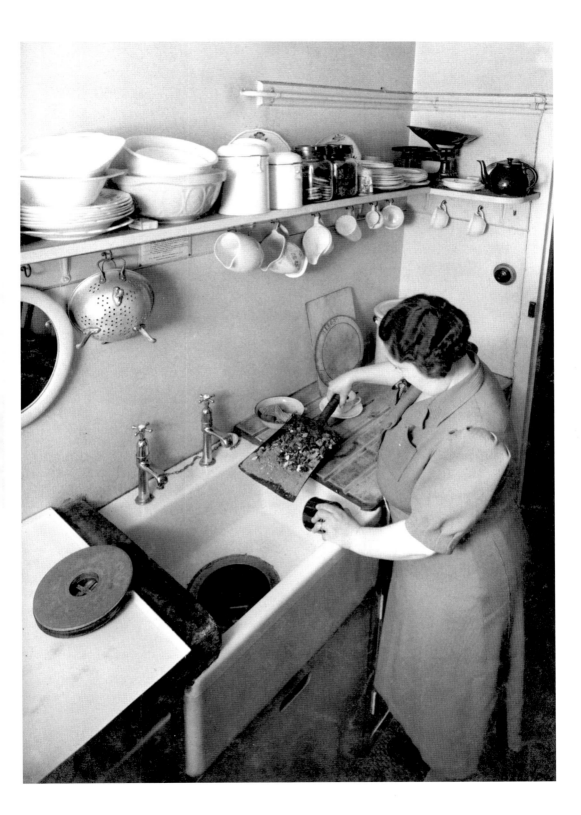

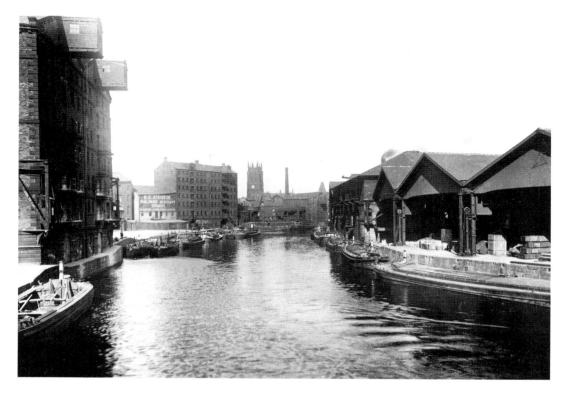

Above: New buildings have recently gone up in the centre of the city and a large number of buildings have been converted allowing people once more to consider living in the centre. This photograph shows some of the original warehouses on the waterfront, *c.* 1916. The tallest building in the centre on the waterfront still stands and is now No. 32 The Calls with a restaurant and apartments above it. The Aire and Calder warehouse seen to the left on Warehouse Hill was built in 1827. Today only the stone arches on the ground floor remain of this building – the rest was demolished and rebuilt as flats and apartments.

Left: The former Wellesley Hotel on Wellington Street, originally the Great Northern Hotel serving the Central Station, has been renamed City Central and is now converted into sixty-five apartments.

three

Industry

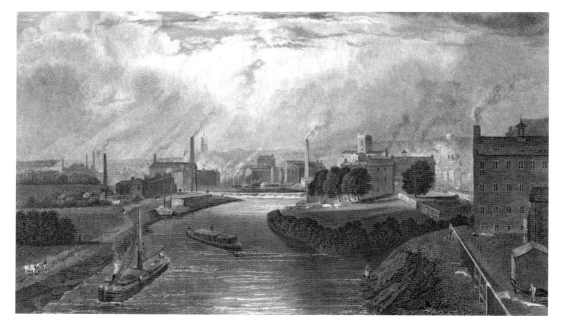

This engraving by J. Cousen shows the smoking chimneys of the Leeds industrial landscape. Up to the late eighteenth century Leeds remained a pleasant rural town surrounded by fields, but between 1790 and 1840 the age of the factory had arrived and the skyline was dominated by mills, foundries and dye works.

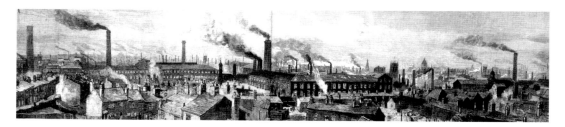

This dramatic panorama of Leeds first appeared in *The Graphic* of 18 July 1885. By this time the textile industry was in decline and engineering was now becoming the dominant force in Leeds. Firms such as the Hunslet Engine Co., Greenwood & Batley and Tannett Walker were major employers. Other industries were also contributing to the air pollution – leather, chemicals and printing were all thriving by the end of the nineteenth century.

Opposite below: John Marshall's flax spinning mill. This copy of the Temple of Horus of Edfu was built on the 2-acre site and was designed by engineer David Roberts and architect Ignatius Bonomi. Marshall was fascinated by Eygptian culture and flax-spinning had been one of ancient Eygpt's important industries. Temple Mill was built between 1838–1840. It was a unique building, boasting air-conditioning ducts, the largest single room in the world, a giant obelisk for a chimney and a glass roof for lighting, later covered in grass for sheep to graze on.

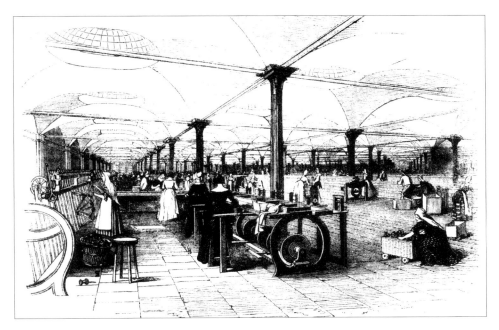

Above: John Marshall came to Leeds in 1790 and built a factory in Water Lane. This drawing of Marshall's Mills showing operators at their machines was published in the *Penny Magazine Supplement* of December 1843, entitled A Day at a Leeds Flax Mill. The flax industry in Leeds peaked in the 1850s and employed nearly 10,000 workers, mostly Irish women, and some children.

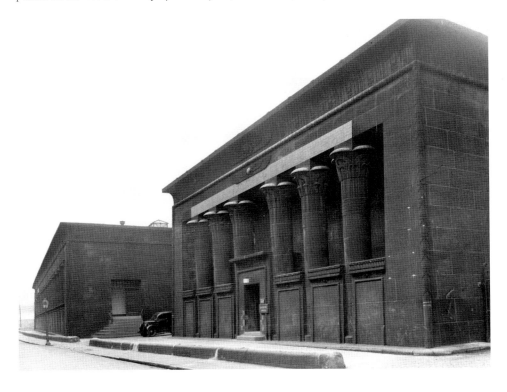

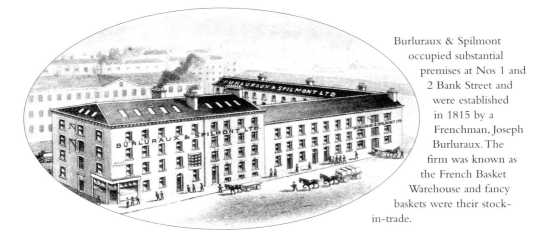

Burluraux & Spilmont occupied substantial premises at Nos 1 and 2 Bank Street and were established in 1815 by a Frenchman, Joseph Burluraux. The firm was known as the French Basket Warehouse and fancy baskets were their stock-in-trade.

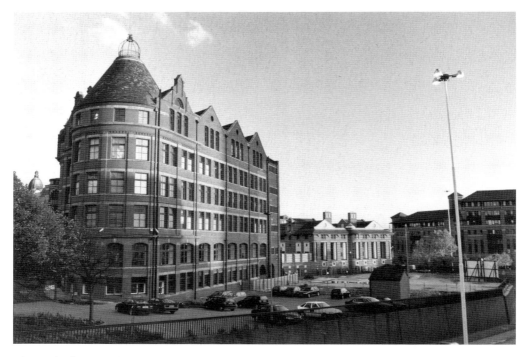

Above: The fortunes of Leeds were built largely on the woollen industry and later the clothing industry. This 1999 photograph shows the former clothing factory Marlbeck House, later known as Centaur House in the 1960s. It was built in around 1922 and after the closure of Centaur Clothes in 1991 the building was converted into forty-one apartments and a leisure centre.

Opposite below: This was originally built for Heatons ladies clothing factory in 1914. Henry Heaton and his son William started the business in 1899, in premises at 41 York Place. The firm moved into Heatona House, as it was then known, in July 1916. *The Yorkshire Post Tercentenary Supplement* of July 1926 describes the building as being built on 'modern fire-proof lines', with light and airy workshops. It was a far cry from the cramped and unhealthy working conditions of clothing industry workers of the previous century.

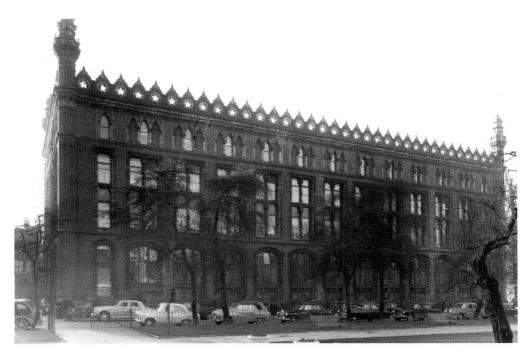

Above: This graceful and elegant warehouse was built, in the Moorish style, by Thomas Ambler for John Barran in 1877. Ambler designed many of the buildings in Boar Lane, as well as the Victoria Arcade. Known as St Paul's House, the interior has recently been completely transformed and is now used as offices.

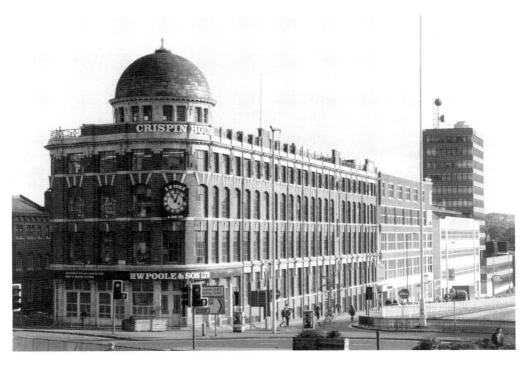

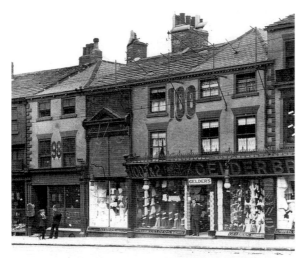

This was the first of four cloth halls to be built in Leeds to cater for the producers of undyed cloth. This had previously been sold at the general cloth market in Briggate. The Leeds White Cloth Hall was opened on 29 May 1711. Leeds historian Ralph Thoresby described it as 'A stately hall, built on pillars on arches in the form of an exchange, with a quadrangular court within'.

The mixed or coloured cloth makers were still using the market in Briggate and they too wanted a cloth hall of their own. A piece of land in the 'Park' was bought from Richard Wilson. The hall was financed by the clothiers themselves who contributed between £2 10s and £7 10s each. It is now the site of City Square and Infirmary Street. The hall cost £5,300 and opened in 1756. It was demolished in 1890.

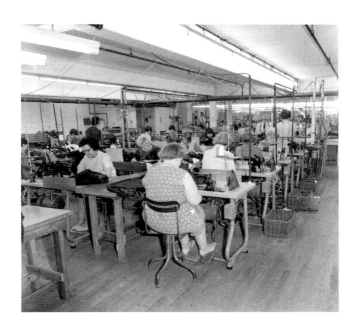

Women work at their sewing machines in the factory of David Little & Co. Ltd, wholesale clothiers. This photograph was taken on 3 December 1970 at their premises in Park Place. The company was established in Leeds in 1853 by two Scottish brothers who had settled in Leeds, David and John Little.

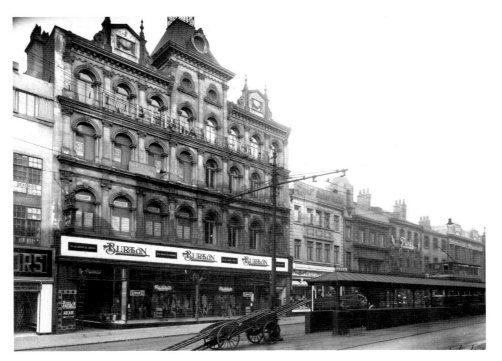

Montague Burton was an enlightened employer committed to improving the working conditions of his employees. He came from humble beginnings. He was born in Lithuania in1885 and arrived in Britain, aged fifteen, with the intention of setting up a business in this country. He started businesses in Chesterfield and Sheffield first and did not arrive in Leeds until after 1910. His business boomed and by 1925 his wholesale made-to-measure service was the largest of its kind in the world. This photograph shows Burton's at 42-46 Briggate.

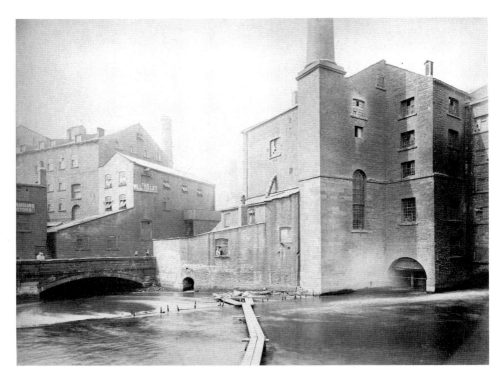

Above: The waterfront in Leeds was once the scene of many thriving industries. These days, it is better known for being a desirable place to live for young urbanites with a growing bar and restaurant culture. This photograph of Concordia Mill, Tenter Lane was taken in 1892 when a mill had already stood on this spot for at least fifty years.

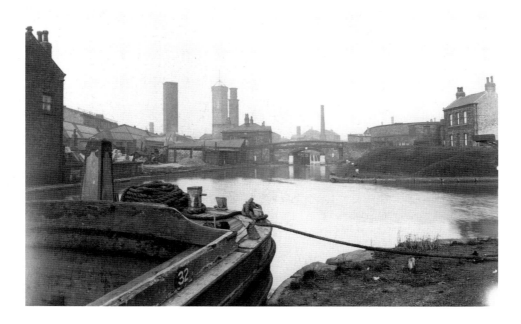

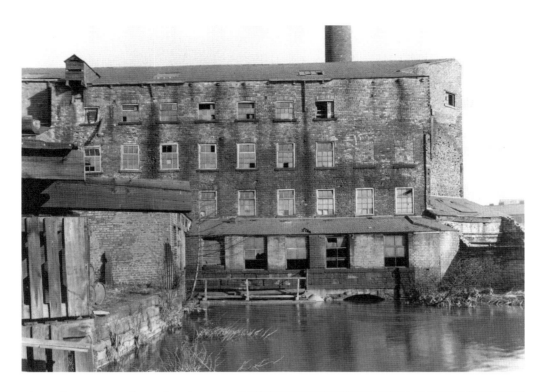

Above: This ancient mill, seen here in 1954, was demolished in 1957 having stood on the site for 200 years. It was originally a corn mill and was used for the last eighty years of its existence by James Richardson & Co. Ltd, manufacturing chemists.

Right: The interior of Nether Mill in 1954 showing the giant waterwheel that was saved from demolition. The wheel was used for hoisting sacks of corn up to the fifth floor.

Opposite below: This view from 1951 looks west towards Cross Bridge, near to Granary Wharf. A boat can be seen moored in the foreground. In the background is Tower Works on Water Lane, Holbeck, with two famous Leeds landmarks, the Giotto and Verona Towers, built in the style of Italian campaniles.

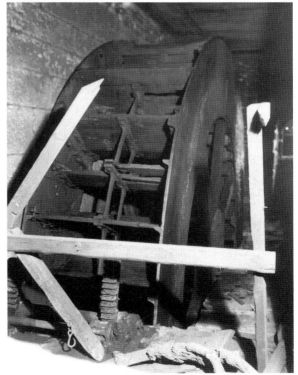

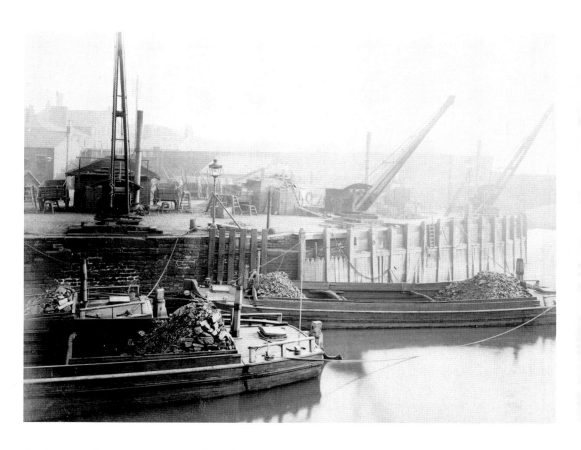

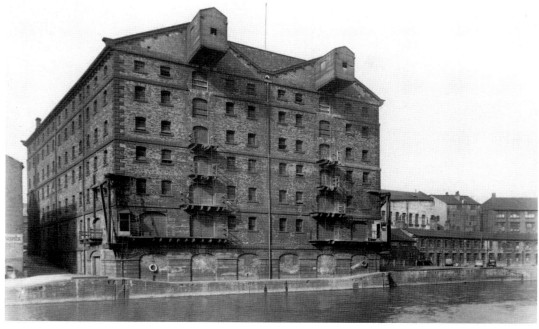

The 'social, moral and religious welfare of the river and canal population of Leeds' was overseen by the Riverside Mission, some of whose members can be seen here, in 1916. There was a great deal of alcohol abuse amongst working men at this time, partly, no doubt, associated with the monotonous and grinding work. Mission members worked to help men and their families from succumbing to the 'evils of the demon drink'.

Opposite above: The rich coalfields around Leeds placed the town at the forefront of the coal industry and the Aire & Calder Navigation provided cheap transport for coal supplies out of Leeds. This is the Leeds Industrial Co-operative Society coal wharf in February 1903.

Opposite below: These Aire & Calder Navigation warehouses have now been demolished apart from the stone arches on the ground floor and rebuilt as residential accommodation. This stretch of the waterfront was known as Warehouse Hill and fronted on to Call Lane.

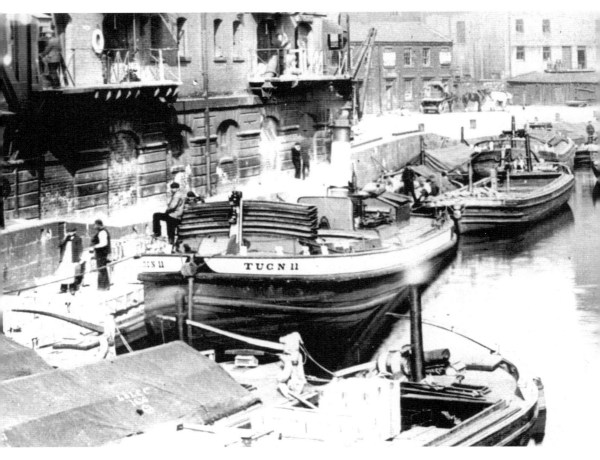

A view of Warehouse Hill, on the north side of Leeds Bridge, probably around 1900. The large building on the left was built in the early 1800s for the Aire & Calder Navigation and was used to store the goods that had been unloaded from the flyboats, or barges.

Opposite above: Leeds Bridge in 1945 during repainting work. One of the most interesting claims to fame for Leeds Bridge is that it featured in what was one of the first ever moving pictures. In October 1888, Louis le Prince made the famous film showing traffic and people on the bridge. Le Prince later disappeared in mysterious circumstances and was never seen again.

Opposite below: This photograph probably dates from the turn of the twentieth century, when the river was a hive of activity. In the background can be seen part of Sparrow's Wharf, which is now a grade II-listed building at No. 32, The Calls. In 1994/5 it underwent a radical conversion to residential apartments and on the lower level became a waterfront bar and restaurant. Most of this stretch of the waterfront has undergone a similar transformation, and the Leeds Waterfront has become an integral part of the city once again in the twenty-first century.

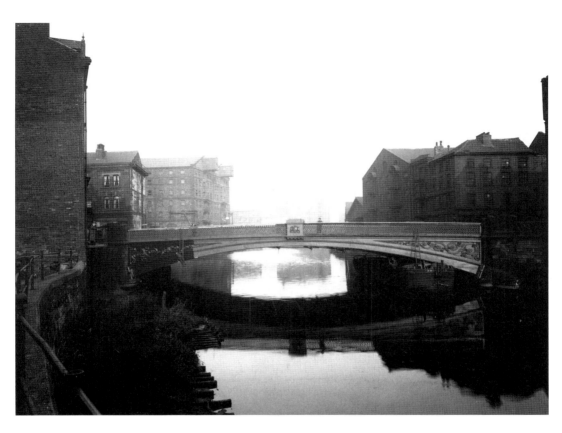

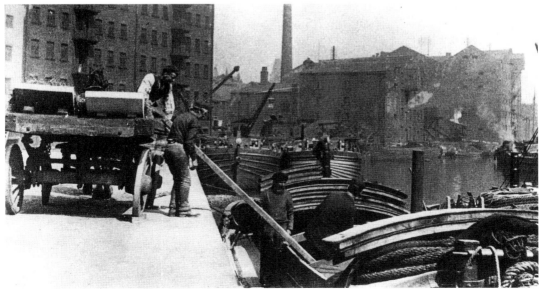

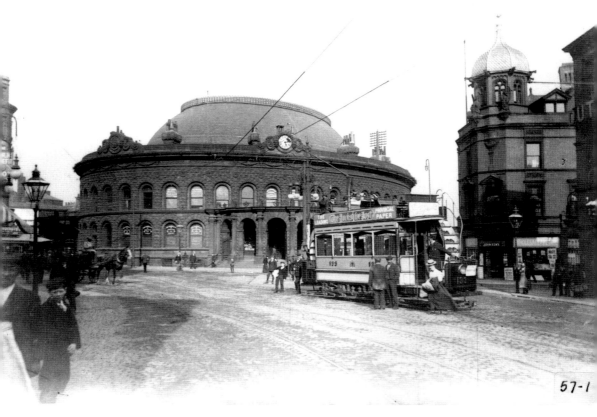

The original Corn Exchange in Leeds was built in 1829 and stood at the top of Briggate. It was demolished in 1869 after the newer and bigger Exchange seen here, designed by Cuthbert Brodrick, was opened in 1863. The Exchange was used by corn dealers who came here to buy and sell their produce.

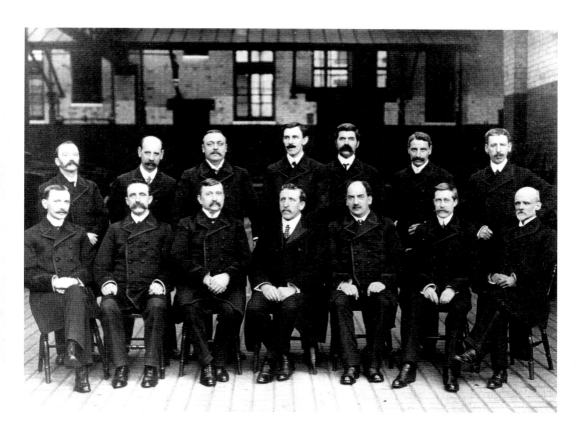

Above: A group of Leeds Post Office Inspectors, photographed in 1897, a year after the General Post Office in City Square was opened. This was a prestigious new building for Leeds, and the postmaster at that time was James Wilson. The new post office was open from 7 a.m. to 10 p.m. Monday to Saturday, and 7.30 a.m. to 10 p.m. on Sundays. There were six deliveries a day, so one could post a letter in the morning and the recipient, if they lived in Leeds, would receive it later the same day.

Right: Another famous Leeds business was started by a refugee from Eastern Europe. The Polish-born Michael Marks, born in Bialystock in 1863, arrived in Britain in 1884 and opened his now famous Penny Bazaar stall in Leeds Kirkgate Market. 'Don't ask the price, it's a penny', was his slogan for many years. The modern M&S store is now universally recognised as an integral part of every British high street. Here we see the Leeds store on Briggate in 1999.

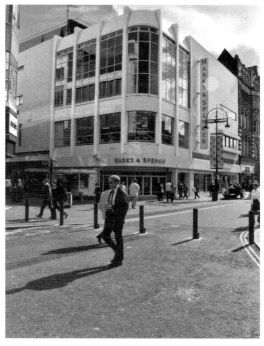

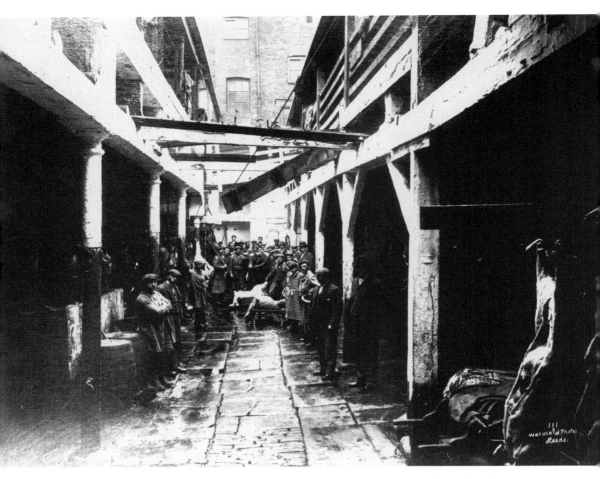

Above: This dirty and unsanitary-looking slaughterhouse, off Vicar Lane, was one of several in the city centre. These were all replaced in 1899 by a new public abattoir and wholesale meat market at the junction of Harper Street with New York Street. A magnificent building, it cost over £25,000 and the Markets Committee spoke with pride of 'the improved sanitary conditions under which the business will be conducted'. This photograph was taken in 1893.

Opposite above: Interior of the Crown Point Printing Works on Hunslet Road before being destroyed by fire on 30 September 1894. This factory replaced the original that had also been destroyed by fire in 1880. Alf Cooke, founder and proprietor, was a great believer in first impressions and the main entrance hall of the new premises were decorated with hanging baskets and cages of singing birds. After this building was lost in 1894, Thomas Ambler built a new factory. The new building, with its distinctive clock tower, can still be seen today.

Opposite below: Founded in 1837, Edmondson's Stuff Warehouse in Alexander Street was a household name in Leeds for many years. Thomas Edmondson and his wife began their business in a little cottage on Alexander Street, when the neighbourhood surrounding the row of cottages was almost rural – the Town Hall, Education Offices and Municipal buildings had yet to be built, and a private residence called Park House stood on the site of the Town Hall. Their son, Thomas jnr, started one of the very early mail-order businesses.

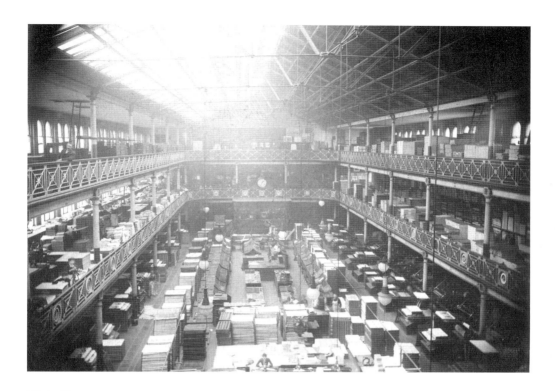

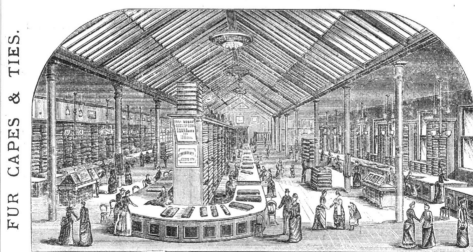

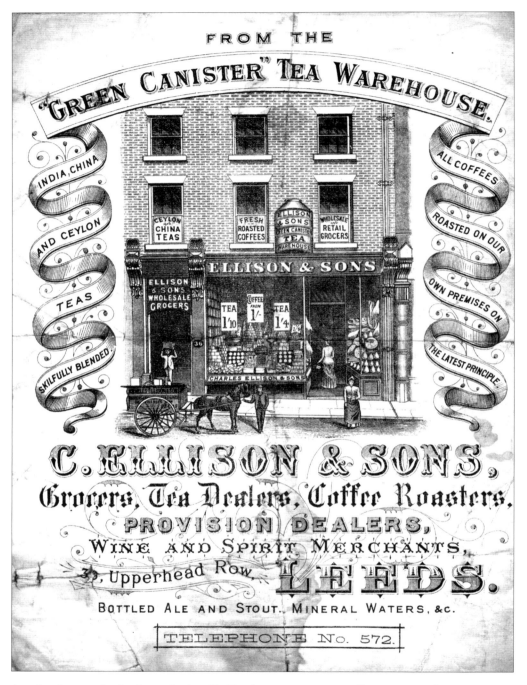

An advertisement for the Green Canister Tea Warehouse, proprietor C. Ellison & Sons, of 35 Upperhead Row. Little is known about this company, but the elaborate and detailed design is typical of the period. The company operated in Leeds from around 1876 to the middle of the twentieth century. This advertisement must date from after 1880 since it has a telephone number at the bottom and Leeds did not have a telephone service before that time.

four

Shopping

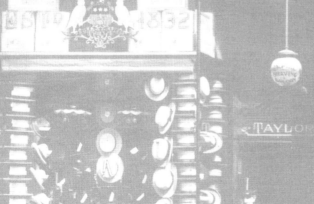

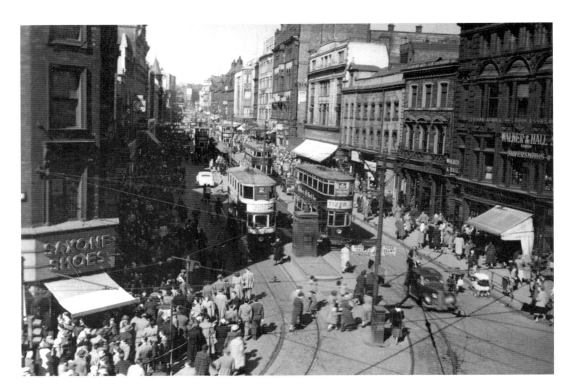

Briggate, meaning 'the road from the bridge', developed as the town grew up along this street which ran north from the crossing point on the River Aire. A charter was granted by Maurice Paynell, the Lord of the Manor in Leeds in 1207, to build a 'new town'. Briggate became established as the main street of the town as well as the site of the market and the centre of trade and commerce. This photograph from 1951 shows Briggate from the junction with Boar Lane.

The last surviving bow-windowed shop on Briggate, No. 51, was next to the entrance to Turk's Head Yard and is seen here in around 1900. The shop was demolished in 1922. This shop, typical of the shops that would have lined Briggate in the nineteenth century, was owned by William Green & Son, grocers and had previously been owned by Buck & Jackson, also grocers. The sign over the entrance to the yard advertises Whitelocks.

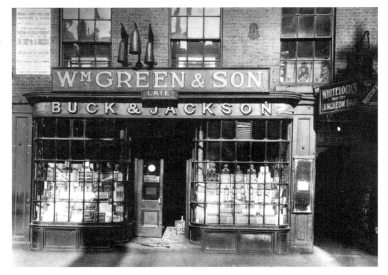

Boar Lane, looking from Briggate, in around 1867. C. Pullan's Central Shawl and Mantle warehouse can be seen on the corner to the right with Bissington, hatter and hosier, to the right of Pullan's on Briggate. This corner was later to be Saxones shoes, Leeds bargain corner. This photograph was taken just prior to the south side of Boar Lane being demolished in an improvement scheme which widened the street from 21ft to 66ft. All the buildings seen

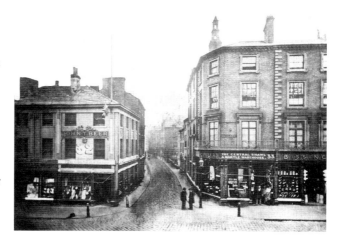

here to the left were demolished, including the premises of John T. Beer on the corner. He became famous for distributing volumes of his poetry advertising his clothing business.

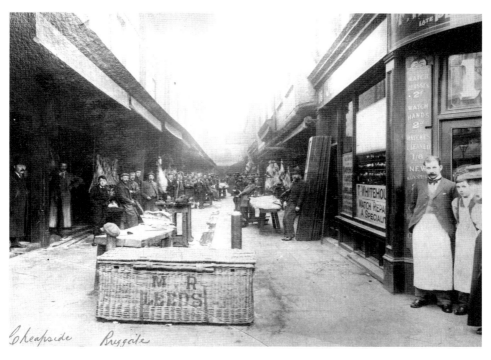

A butchers' shambles (market) had been here since the Middle Ages and was called Middle Row because it was built in the centre of Briggate, just above the junction with Kirkgate. The butchers' shambles occupied one side and the raw wool market the other. Animals were also slaughtered here. Middle Row was removed in 1825 as it had become an obstruction in one of the city's busiest streets. The shambles was moved to an area between Briggate and Vicar Lane and included the street shown here, in around 1899, Cheapside. The area was purchased by Leeds Corporation in 1898 and redeveloped by the Leeds Estates Co. between 1898 and 1903. Cheapside was replaced by King Edward Street.

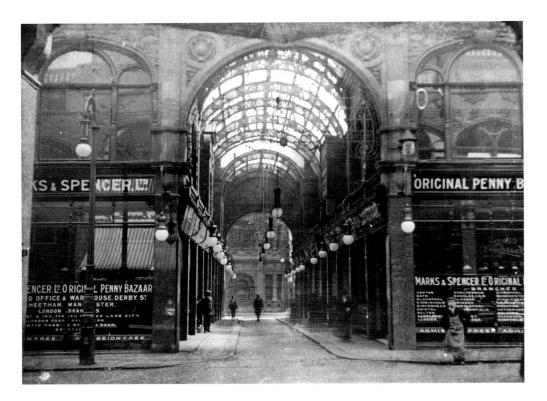

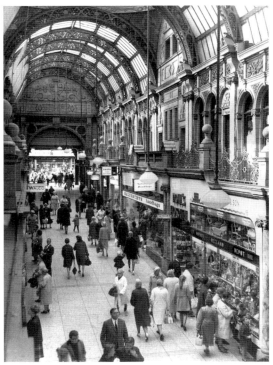

Above: Cross Arcade and County Arcade were designed by Frank Matcham, a London architect, for the Leeds Estates Co. as part of the redevelopment of the area between Briggate and Vicar Lane. This image shows Marks & Spencer to either side of the entrance to Cross Arcade. The interior of the arcade was richly decorated and built two storeys high although there were only shops at ground level. Marks & Spencer had acquired this site in 1904 and retained their old slogan the 'original penny bazaar' for the new building.

Left: County Arcade is shown here in 1967. The building of the arcades and the Leeds Estate Company development helped make Leeds the shopping capital of the north of England in the early 1900s. One firm, Durham's, had shops on Briggate, Queen Victoria Street, and in the County Arcade and sold a variety of fancy goods. They issued a catalogue in 1900 called 'The Transformation of Briggate', which celebrated the new buildings.

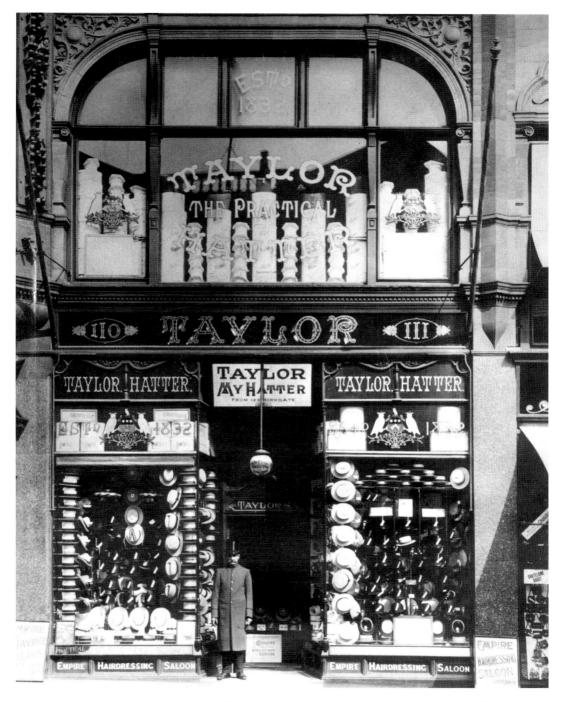

Another business to take advantage of the new premises developed on Briggate was that of John Taylor, hatter. These premises at Nos 110-111 Briggate were next door to the Empire Theatre. The windows display a large variety of hats, and a top-hatted doorman is waiting for customers. The shop signs were made by Farrar Signs of Leeds.

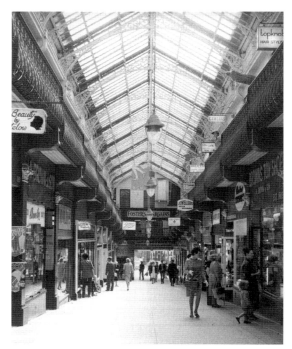

Left: Queen's Arcade, between Lands Lane and Briggate, is seen here in July 1967. It was built in 1889 on the site of the Rose and Crown Yard and was the second arcade to be built in Leeds. It was named in honour of Queen Victoria's Golden Jubilee.

Below: H. & D. Hart at No. 116 Briggate photographed on 25 September 1926. This shop was on the corner with King Edward Street. Hart's, a milliners and furriers, had recently moved from premises on the corner of New Briggate and the Upper Headrow. At this time Matthias Robinson was located at Nos 121–126 Briggate, just to the right of Hart's. In 1938 they took over Hart's business and expanded their premises.

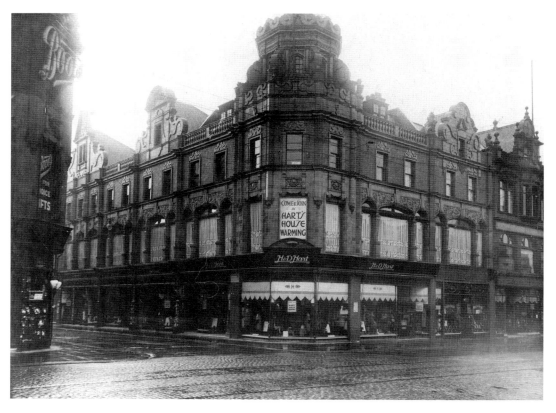

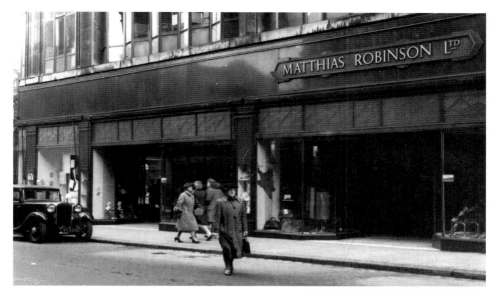

Matthias Robinson Ltd seen here in 1944. The shop had by this time expanded to take over Hart's premises on the corner of King Edward Street and Briggate. The department store was sold to Debenhams in 1962 but the name wasn't changed until 1972.

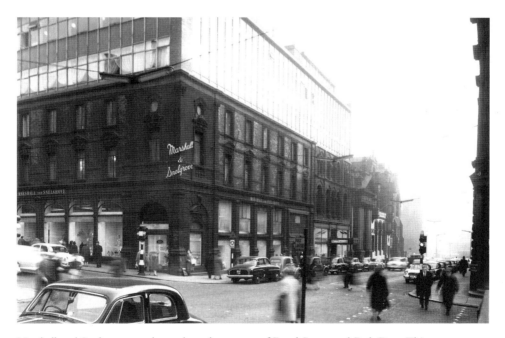

Marshall and Snelgrove was located on the corner of Bond Street and Park Row. This was considered a high-class store selling a wide range of carpets, linoleum, soft furnishings and clothing. The building in the photograph opened in 1870 with the upper storeys being added at a later date. The company later became part of the Debenhams Group but the shop closed on 13 February 1971 and was demolished later to be replaced by Lloyds Bank.

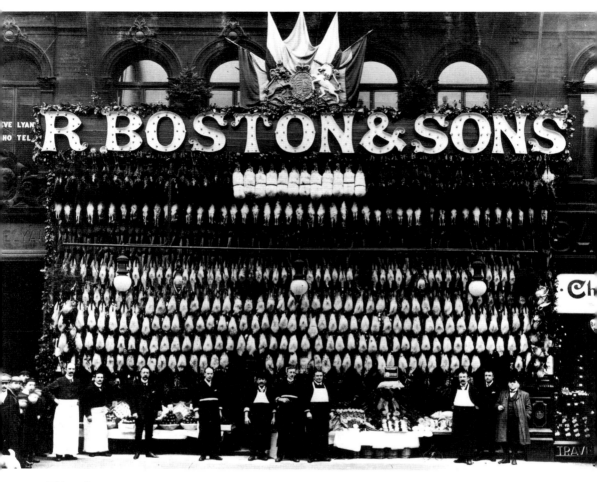

This early 1900s image shows Boar Lane, home to some of Leeds most stylish shops, including Mr Richard Boston & Sons, a great fruit, game and fish market. The store was described in Waddington's 1894 *Guide to Leeds* as providing fifty varieties of fish, including oysters, every bird imaginable, thirty-six varieties of vegetables, one hundred sorts of fruit and '...a selection of luxuries too numerous to name and a business-like briskness in attention to the smallest order are within the customers reach'. Mr Richard Boston (1843-1908) was a member of Leeds Council for twelve years and an elected member for the Headingley Ward in 1891. As chairman of the planning and property committee he bought six new parks for Leeds and donated the statue of John Harrison for City Square and items of art to the Leeds art gallery. Widely known through the north of England as a successful merchant, he was a prominent Leeds citizen and lived at Croft House, Burley Road.

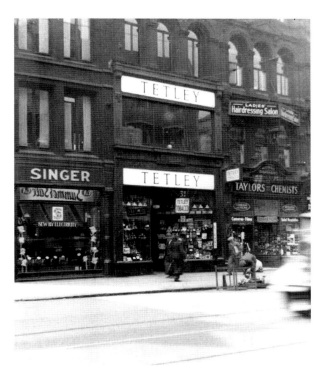

Boar Lane in 1938 showing some
of the shops. Left to right are Singer
Sewing Machines, Tetley Tobacconists
and Taylor's Chemist. Above Taylor's is a
ladies hairdressing salon.

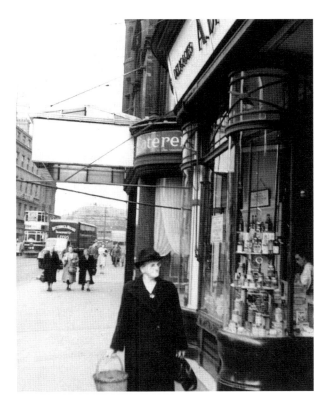

Post-war shopping in Boar Lane, 1946.
The shop fronts of a caterers and a
delicatessen are in view.

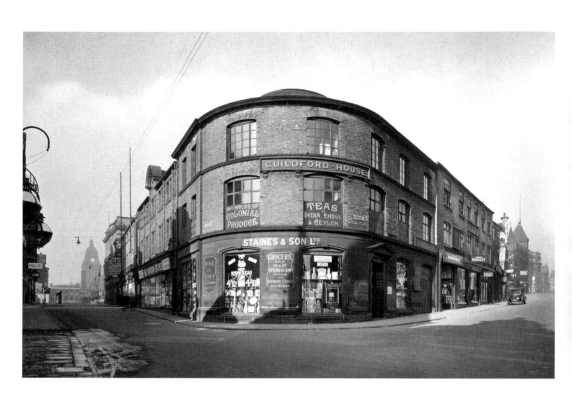

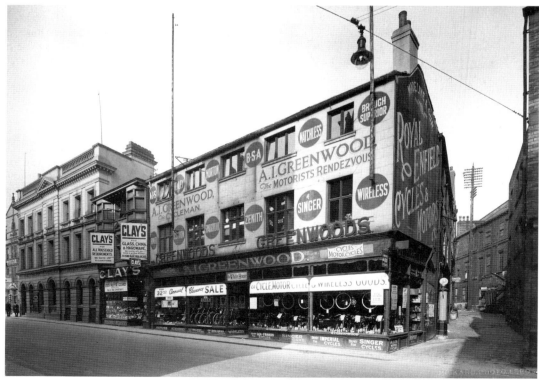

These are the premises of George Eastwood, tobacconist, at No. 24 Guildford Street seen here in the 1920s. The shop was at the junction with Albion Street and one of five single-storey shops that were around 200 years old at the time. This was the westward limit of the ancient Leeds boundary; the Burley Bar stone was set in the wall here. It was to be demolished for improvements to what was to become the Headrow. In 1924 the Leeds and Holbeck Building Society bought the site to build new headquarters. The Burley Bar stone is now kept in this building. The Eastwood business relocated to No. 97 Headrow, near Schofields.

Opposite above: Grocery shopping was possible in the city centre in shops such as this one owned by Joseph Staines. Guildford House with its curved frontage had been on this site since at least 1847. This photograph taken on 14 October 1928 shows the junction of Guildford Street with Woodhouse Lane shortly before the buildings on the north side of Guildford Street were demolished as part of the plan to widen what is now the Headrow and create a new east-west route through Leeds. When Guildford House was demolished Staines & Son relocated to Wade Lane.

Opposite below: Alfred Greenwood advertised his shop on Guildford Street as 'the motorist's rendezvous'. He had extended his shop in 1911 to give 800ft of ground floor space for storage; above was a showroom. Greenwood provided free storage space for National Cyclists Union members when visiting the city. This photograph was taken in 1928.

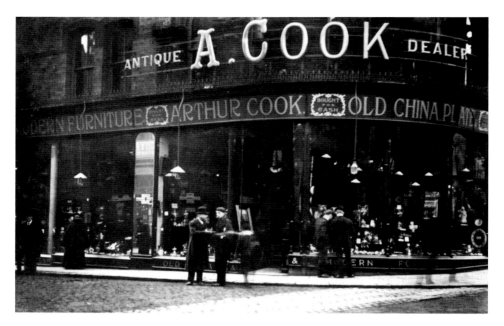

Shopping around the turn of the last century. These photographs were all taken to show the shop signs done by Farrar Signs of Leeds and come from the McKenna collection. They show good examples of shops of the period. This photograph from around 1900 shows Arthur Cook, furniture and antique dealer, who had premises at No.13 Upperhead Row.

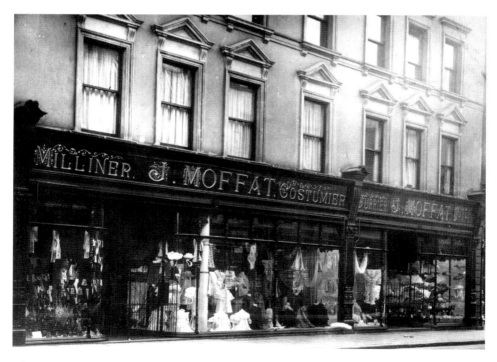

John Moffat's millinery shop on Bond Street also stocked ladieswear and drapery.

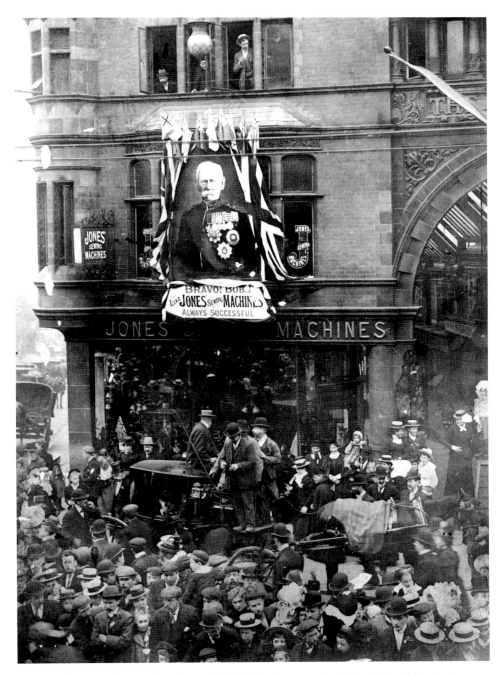

A view of Jones sewing machine shop, with Merrion Street on the left and Grand Arcade to the right, in 1901. A large crowd of people and horse-drawn vehicles are gathered. The Boer War was being fought at the time and on the shop front is a tribute to Lord Roberts, one of the leading military commanders of the period. Under his portrait is the slogan 'Bravo!' 'Bobs, like Jones Sewing Machines, Always Successful'. 'Bobs' was a nickname given to Lord Roberts by poet Rudyard Kipling, who greatly admired his military achievements.

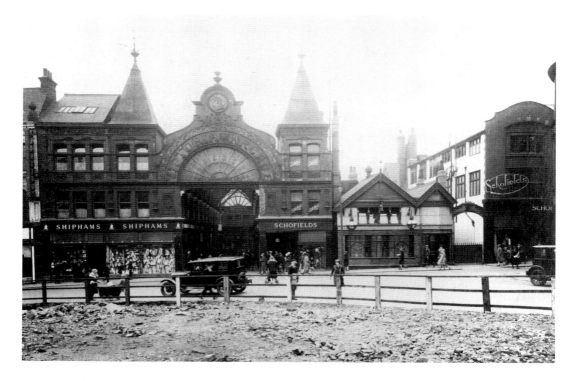

Above: Victoria Arcade on the Headrow in 1930 seen
from the site cleared for Lewis's Department store. It was
L-shaped and connected the Headrow with Lands Lane.
The arcade had twenty-six shops, each with a showroom
above. The Upperhead Row entrance was decorated
in faience, with an image of Queen Victoria in the
centre. To the left is Shiphams and to the right is part of
Schofields store, opened in 1901 by Snowden Schofield.
He gradually expanded into neighbouring properties,
including the historic Red Hall on the far right of this
photograph. To the right of the original shop is the Cock
and Bottle Inn, which was sold to Schofields in 1938
and demolished for store expansion. In 1961 the site was
redeveloped into a new Schofields store but is now the
site of the Headrow Shopping Centre.

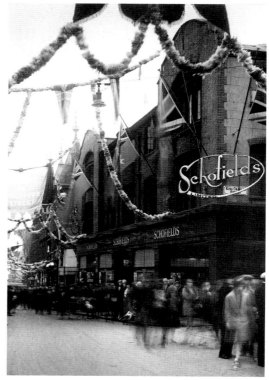

Right: Another view of Schofields department store on
what is now the Headrow, formerly Guildford Street.
The street is decorated for Civic Week, in September
1928, with garlands and bunting. A large banner with
the words 'Welcome to Guildford Street' is visible. As
part of the celebrations, competitions were held for the
best decorations. Schofields won first prizes in three
categories: Things to wear, Things to use and Best
General Display for two or more windows.

Right: Denby & Spinks store on Albion Street, *c.* 1900. This firm was founded in 1850 by Alfred Denby and joined from 1870 by Albert Spink. The original premises were a warehouse in Albion Place but in 1876 they acquired the premises shown here in Albion Street. This building had formerly been the Music Hall. The photograph shows two horse-drawn carriages outside the shop. The store was sold in 1958.

Below: This photograph taken in September 1928 shows the prize-winning window displays of Finglands Furnishing, situated at the junction of King Charles Street and Guildford Street. As part of the Civic Week celebrations shops and street were decorated.

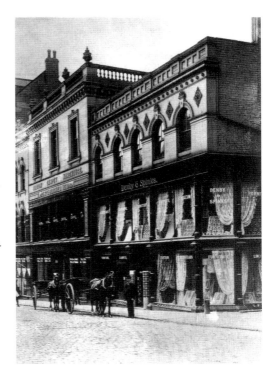

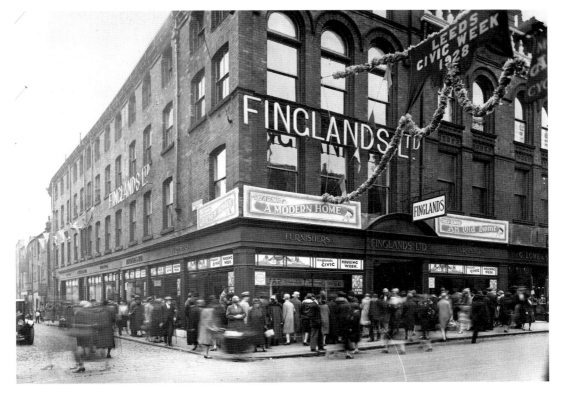

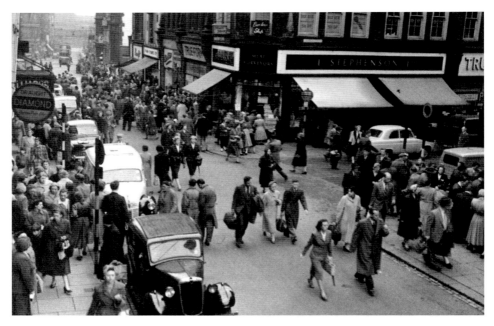

A busy shopping day on Kirkgate in 1956. I. Stephenson Ltd. butchers; True Form Boot Co. Ltd, boot and shoe dealers and Chic Modes Ltd, ladies outfitters, can all be seen.

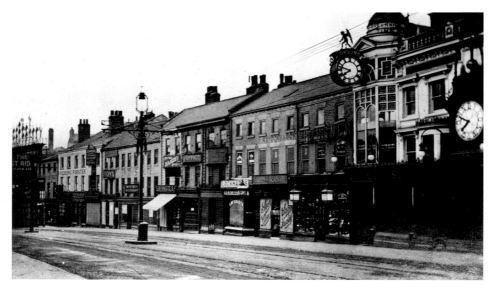

A regular meeting point for Leeds people at one time was under Dyson's clock. This 1903 image shows Dyson's shop in what is now the grade II-listed Time Ball Buildings on Briggate. They date from the early nineteenth century but much of the elaborate façade was added after John Dyson founded the firm here in 1865. The words 'Tempus Fugit' appear on the building and gold lettering displays the date 1865. The gilded time ball mechanism was synchronised with Greenwich and dropped at exactly 1.00 p.m. daily. Time Ball Buildings is an important example of the decorative shop designs of that period.

By the 1920s the Lowerhead Row was at times almost impassable for traffic. A scheme was approved in 1924 for the widening of the street which would mean the demolition of all the properties on the north side. These shops were photographed on 14 October 1928, shortly before demolition. They included Tolson's tripe shop, run by Mrs Isabella Tolson (probably the lady in the doorway)

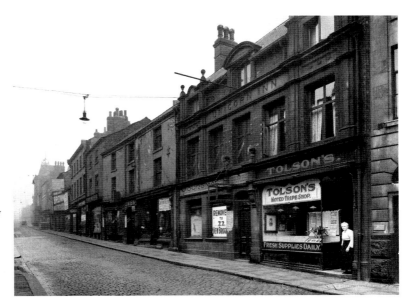

and Youngman's fish and chip shop and restaurant. By this date Youngman's had relocated to Briggate. Both shops were housed in what had previously been the Unicorn Inn.

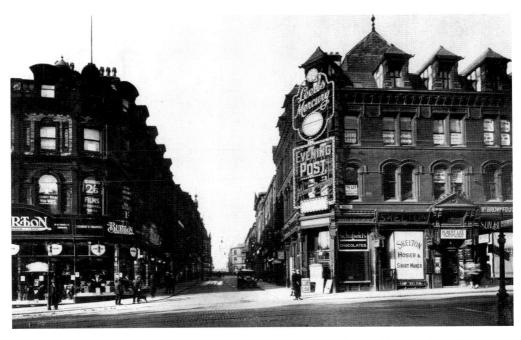

This shows just how narrow the Upperhead Row was before the road was widened and the Headrow created. This view in October 1928 is from the Lowerhead Row looking across Briggate along the Upperhead Row. On the left is Montague Burton's premises. The shops to the right in the photograph were soon to be demolished and Lewis's store built on the site.

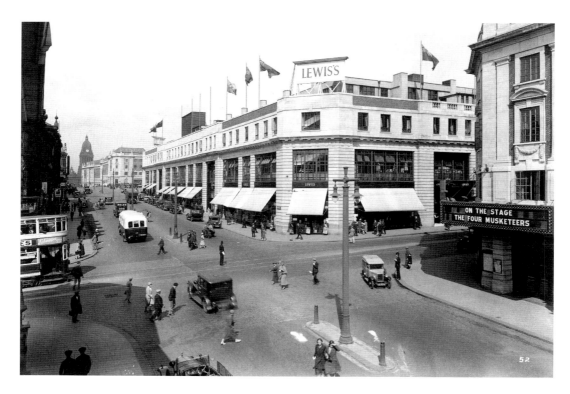

Above: The same junction after the building of Lewis's, July 1934. New Briggate is to the right after the Odeon Cinema. This was one of the largest stores, at the time, to be built in the north of England. Work began in 1930 and although the store opened on 17 September 1932 it was not fully completed until 1939, when three more floors had been added. The architect was G.W. Atkinson, and like the other new Headrow buildings, was designed by Sir Reginald Blomfield. On the first day of opening over 100,000 people visited the shop.

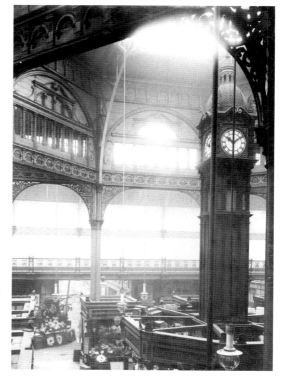

Right: Kirkgate Market seen in September 1911. The central clock was by Potts & Son and was moved to Oakwood in July 1912 by the Parks department when a central entrance was created on Vicar Lane. An open market had been on this site from the 1820s; the cow and pig market had moved there in 1822, as had the fish and wholesale fruit and vegetable markets. It continued to expand and a covered market was opened in 1857 ending 650 years of street markets in Briggate. Kirkgate Market continued to expand and in 1875 Leeds New Market was built. The present building opened in 1904 and was designed by John and Joseph Leeming of London and the final cost was £116,750.

City
Landmarks

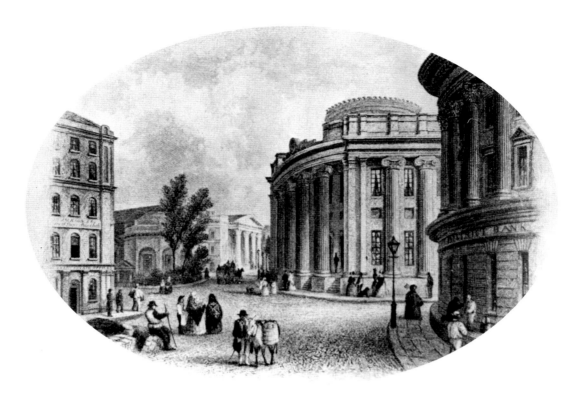

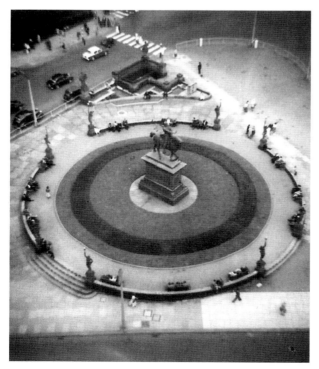

Above: A rare image of the site now occupied by City Square. This engraving, by J. Clark, shows Bishopgate Street to Park Row in 1826. On the left is the courthouse with the Coloured Cloth Hall partly obscured by trees. The Commercial Buildings, built 1826–29, are in the centre, with the District Bank on the right. In 1893, the city fathers decided to create an open civic space, and this was to be the location for it.

Left: A dramatic view of City Square, seen from the roof of the Queen's Hotel by painters and decorators employed by Marsh, Jones & Cribb Ltd of Beeston who were working on the roof of the hotel at the time, *c.* 1950. The road in front of the General Post Office building, top left, was closed to traffic in 1966. People can be seen seated between the statues of Morn and Eve, with the statue of the Black Prince in the centre.

A striking view of City Square taken in June 1934 showing the Black Prince statue and one of the eight 'Morn' and 'Eve' statues by Alfred Drury, R.A. The statues were unveiled at the official opening of the square in 1903. They were removed in 1961 when the square was remodelled. When they were not immediately replaced suspicions of their possible sale led to protests but the nymphs were finally restored to the square in 1962, after an offer of £2,000 for them had been turned down!

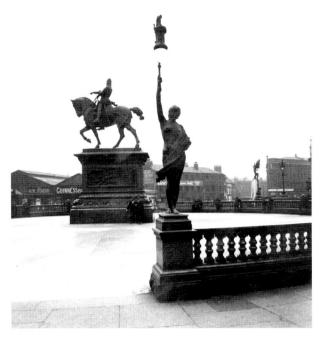

Dr Walter Farquar Hook was Vicar of Leeds from 1837 to 1859 and was known for his sweeping reforms of the church in Leeds. When he arrived in 1837 the old parish church was in a poor state of repair. By 1841 he had changed all of this and a new parish church had been built, with a new peal of bells and a new organ. He had great affection for children and wanted poor children to have the opportunity to have an education to help them to better themselves. To this end, he encouraged the church to build schools out of church funds. This photograph was taken in 1972.

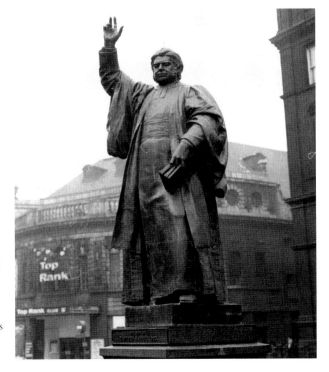

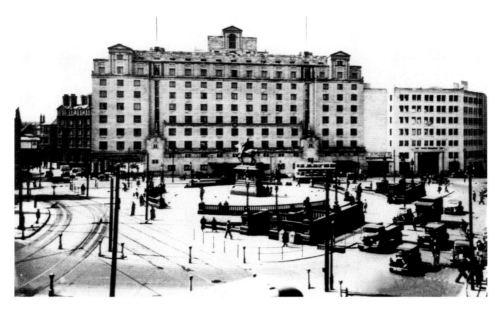

The new Queen's Hotel, seen here, was opened by the Earl of Harewood on 12 November 1937 and replaced an older building on the same site. Every room had central heating, air conditioning and en suite facilities. The road leading to the railway station was even paved with rubber slabs to reduce the noise of the traffic. It was intended that the hotel should rival the best that London could offer and one of the architects was W. Curtis Green, who had designed the interior of the Dorchester in London.

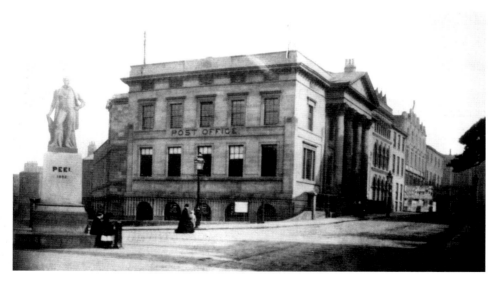

Originally built as the courthouse and designed by Thomas Taylor, the foundation stone for this building was laid by the Mayor on 2 September 1811 and opened in 1813. In 1834–35, another floor was added by Robert Chantrell. When the new Town Hall opened in 1858, the courts were moved there, and in 1861 the building was taken over by the Post Office. The new post office opened in 1896 on what was to become City Square and the old building was demolished in 1901.

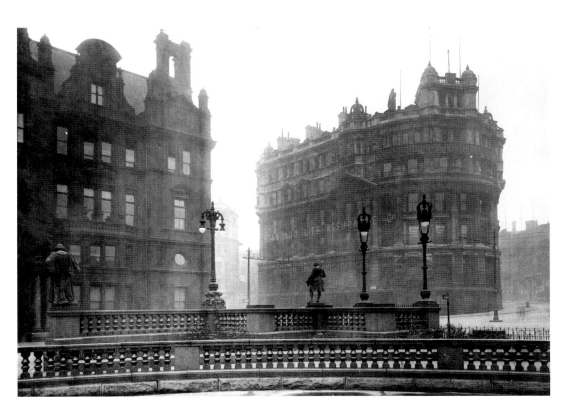

Above: For many years the main post office and sorting office in Leeds, the building seen here on the left was designed by Sir Henry Turner. The Standard Life Assurance building on the right was designed by Archibald Neill and opened in 1901. It was replaced by the Norwich Union building (right), after being demolished in 1963. A small but significant piece of history took place nearby – the first traffic lights in the country came into operation on 16 March 1928 at the junction of Park Row and Bond Street. They were the brainchild of C.S. Shapley, general manager of the Gas Department, and Chief Constable R.C. Matthews.

Right: This uncompromising slab of glass and concrete replaced the graceful and stately building above and dominated the skyline of City Square for over thirty years. In 1989, the *Sunday Times* voted it one of the UK's top ten worst buildings and the citizens of Leeds were not sorry to see it go. This photograph was taken in 1967, shortly after it was opened in March. It was demolished in 1995.

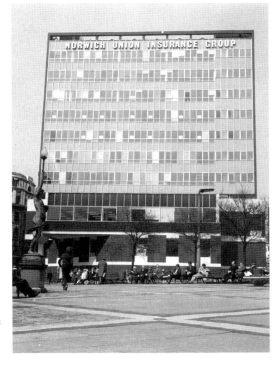

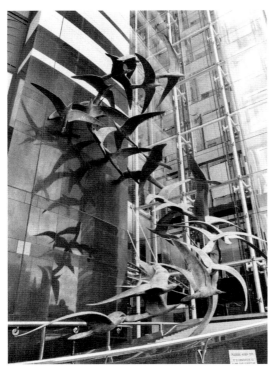

Left: A much more graceful building now stands on the site. Here we see the stunning detail of the sculpted birds flying up the side of No. 1, City Square. Pure white marble from the Greek island of Thassos was shipped to Leeds to build it. This marble is normally used only for royal palaces and the like, but the architects, Abbey Hanson Rowe, chose it for its light reflective qualities and low maintenance.

Below: The first Mill Hill chapel was a modest affair built in 1672 as a Presbyterian meeting house. By the 1840s, the congregation decided that they wanted something a bit grander, so a competition was held to choose a design for the new chapel. The winners were Bowman and Crowther, and it is their Gothic-style building that stands today, resembling an Anglican church rather than the more usual plain, non-conformist churches of the period. The present chapel was opened on 22 December 1848 and has been a prominent feature of City Square ever since.

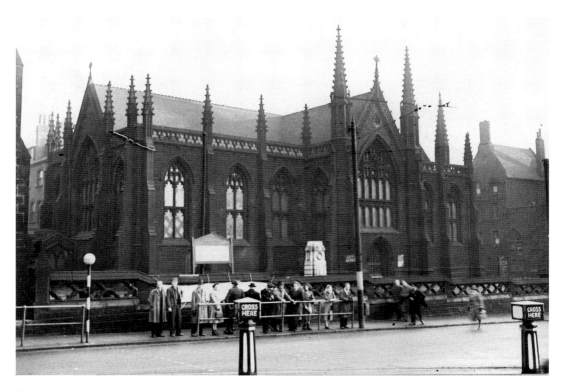

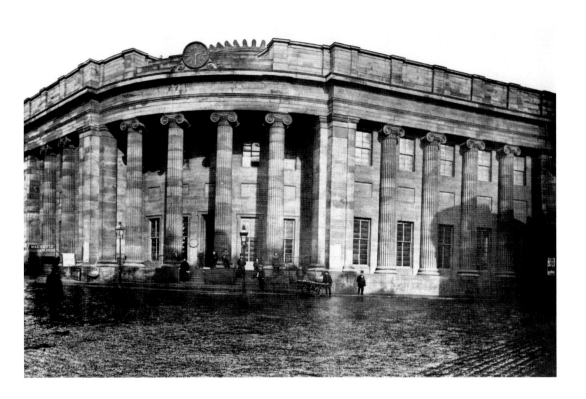

Above: A fine Georgian building, the Commercial Building was designed by John Clark in the Ionic style, seen here in the late 1860s, at the corner of Boar Lane and City Square. The foundation stone was laid on 18 May 1826 and the building opened three years later. Each of the columns was 40ft high and 4ft in diameter, which gives an idea of the scale of the building. It was demolished in 1871 to make way for the fancy turrets of Royal Exchange House. Leeds Castle is reputed to have once stood on this site.

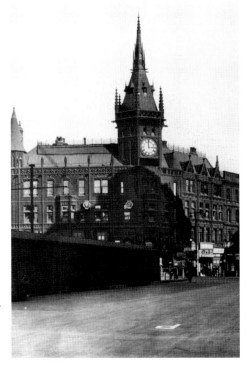

Right: A committee was formed in 1871 under Ald. John Barran to erect a new exchange and newsroom to cater for the increasing diversity of business in the city. The Royal Exchange building was opened in September 1875. The building was decorated with 5ft tall ornamental statues, carved by the renowned Leeds firm of sculptors, John Throp & Sons. One of the sons, Canova, was in such poor health that he was carried to the site and supported by pillows whilst he carved. The statues depicted historical figures including Ilbert de Laci, Maurice Paganel, Sir John Savile and John Harrison. When the building was finally demolished in 1964 the statues were removed to Leeds Museum for safekeeping.

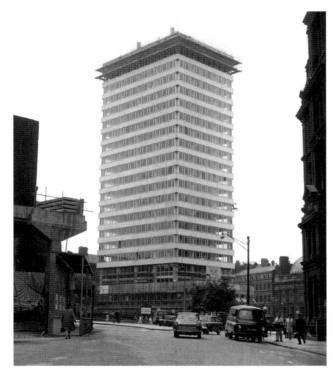

This office block, Royal Exchange House, when it replaced the Royal Exchange Building in the 1960s, was the tallest in Leeds. It is 215ft tall and has twenty storeys, including a penthouse at the top for the caretaker. It was officially topped out on 7 February 1966. The building remained empty for several years and in 2002 work started on major alterations. Dubbed 'the ugliest building in Leeds' (competition for the Norwich Union building on the other side of City Square!) the refurbishment transformed it into the posh Park Plaza Hotel, with new windows and cladding to make it look more modern and stylish.

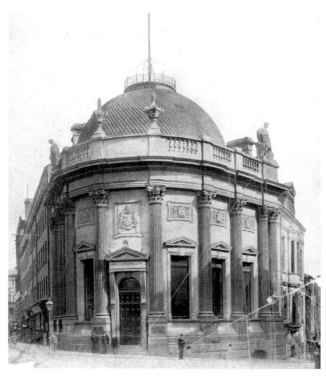

This is the headquarters of the Yorkshire Banking Company on the corner of Boar Lane and Bishopgate in 1899. The building had just opened and was designed by W.W. Gwyther. Built from granite, the building is ornamental with Corinthian columns and balustrading. The statues seen on either side of the roof represent Manufacture and Agriculture. Carved panels above the windows depict the coats of arms of prominent towns and cities where other branches of the Yorkshire Banking Company were situated. The building is topped with a copper dome 40ft in diameter with an iron corona containing a skylight in the centre. It is currently used as one of Leeds' many nightclubs.

Situated on Park Row, this museum building was originally the Leeds Philosophical and Literary Society headquarters, built in 1821 and designed by Robert Chantrell. An air raid in 1941 caused severe damage to the museum and the Park Row entrance was replaced with a concrete frontage. The museum finally closed in 1965. Service was transferred to a floor in the Municipal Buildings which housed Leeds Central Library and adjoined the Art Gallery. The museum was closed in 1999 when the building was renovated. The building on Park Row was noted for its reconstruction of a coal mine, the brain child of the curator Dr David Owen. It featured a cage, coal-faces, conveyors, and coal-cutters and was an immediate hit with visitors.

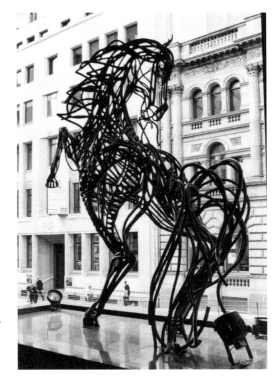

The Black Horse, outside Lloyd's Bank on Park Row, aroused considerable controversy amongst the people of Leeds when it was unveiled on 11 October 1976. 'Needs a good meal' was one of the comments! The sculptor was Peter Tysoe of Devon and the powerful image of a rearing horse made from interconnecting bars of mild steel was apparently meant to reflect the speed and complexity of modern banking.

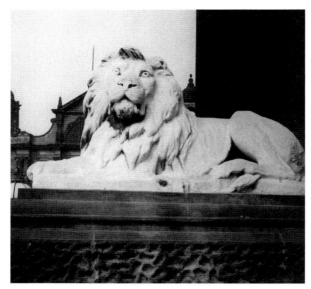

This more traditional work by Hull sculptor William Day Keyworth, earned him £600 from Leeds Corporation. The Town Hall lions retain their whiteness due to the nature of the Portland Stone they are sculpted from – every time it rains, they are washed clean. A local legend claims that the lions come to life at midnight and roam the city, but the thriving club culture in Leeds has probably frightened them away from this!

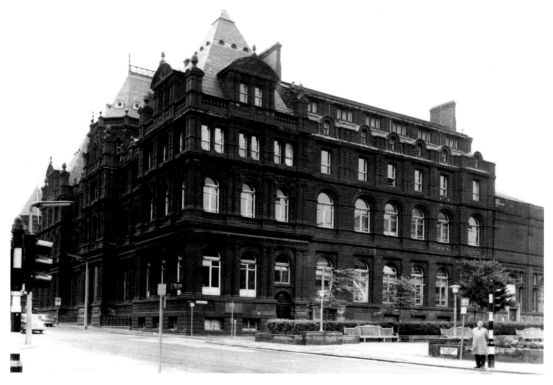

Built in 1884 and designed by architect George Corson, the Municipal Buildings originally housed civic offices and the Central Lending Library. In 1934 the City of Leeds Police Headquarters and Criminal Investigation Department took over the first floor and cells were created in the basement to hold prisoners. A sign saying 'CID' can still be seen on one of the marble pillars on the ground floor. The police moved out in 1966.

One of the finest civic buildings in Britain, the Civic Hall is almost triangular in shape, and was designed to make the most use of light and air. The architect was Mr E. Vincent Harris and it cost approximately £360,000 to build and furnish. It has been estimated that to construct a similar building today would cost around £45 million! There was great unemployment at the time of building the Civic Hall and the construction of it provided work for many local people.

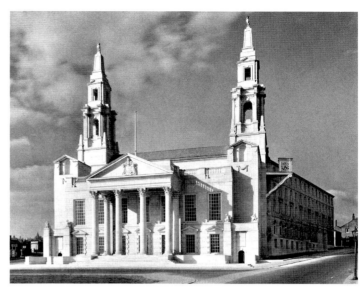

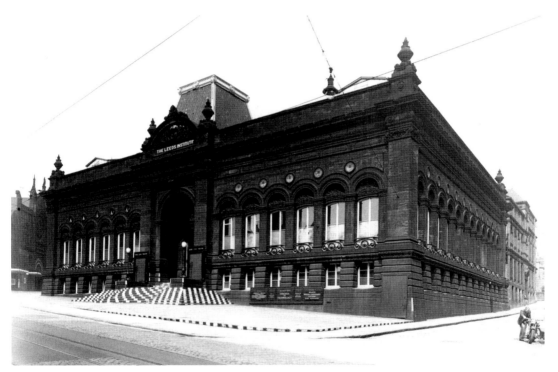

Designed by Cuthbert Brodrick and opened on 18 June 1868 this building was originally called the Leeds Institute of Science and Arts, or the Mechanics Institute – part of the movement to provide education for the working man. As well as a circular lecture hall, which could accommodate 1,500 people, there was also a library, classrooms and reading rooms. In 1949, the lecture hall was converted to house the new Leeds Civic Theatre, and this became a base for many amateur dramatic and operatic societies. The building is currently closed for redevelopment as the new Leeds Museum.

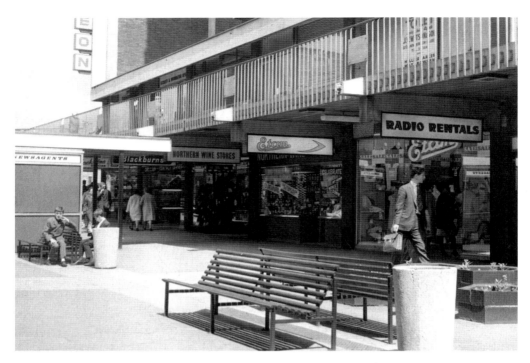

The Merrion Centre was officially opened on 26 May 1964 by Arnold Ziff, then chairman of Town Centre Securities who owned and developed the centre. A promotional guide was published to coincide with the opening and it describes the Merrion Centre as 'a city within a city', boasting 150 tenants which included shops, offices, a bowling alley, a cinema, dance hall, night club, hotel, garage and filling station, and parking for over 1,100 cars.

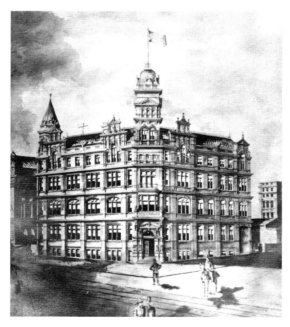

This graceful building, the Leonardo Building, was built in 1897, originally for Fred R. Spark & Son, printers. They occupied it until 1915 when Chorley and Pickersgill, who owned the Electric Press building across the road, took it over. In 1975 it became part of City of Leeds School, before being refurbished and extended to provide extra accommodation for Leeds City Council offices. In 1998 the refurbishment was completed by the addition of a two-tonne iron corona to the tower on the roof of the building. This is a copy of the original dome which once graced the roof, and was designed by council architects John Thorp and Greg Hooks, working from old photographs and drawings. The dome is nearly 14ft high and was made in two halves which were welded together on site before being hoisted on to the roof.

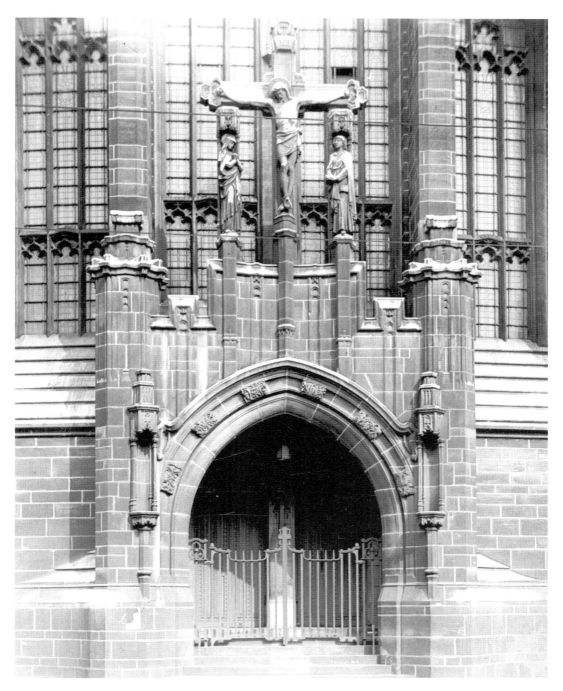

The 'new' St Anne's Cathedral on Cookridge Street replaced an earlier one on Guildford Street which had been demolished during 1903-04 for the widening of Guildford Street. It was designed by John Henry Eastwood and his assistant Sydney Kyffin Greenslade, in Arts and Crafts/neo-gothic style. The eminent architectural historian Patrick Nuttgens once described it as 'one of the best of all the Catholic cathedrals in the country, and probably the most outstanding after Westminster'.

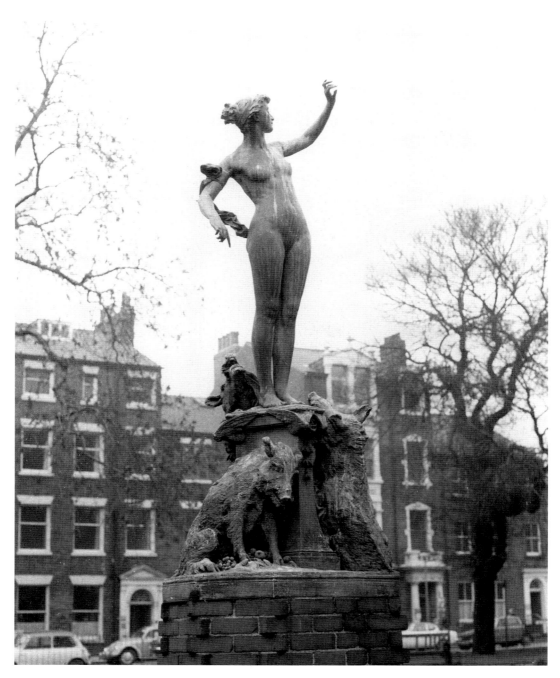

Circe was a beautiful but wicked young goddess who lived on the island of Aeaea. She tempted Odysseus's men with drugged food and wine to make them forget their past, and then turned them all into swine. This 1894 statue of her, by Alfred Drury, in Park Square, originally held an upturned goblet in one hand, and a wand pointing down at the swine grovelling at her feet in the other hand. The statue was bought by Leeds City Art Gallery and received a Medal of Merit when it was sent to the Brussels International Exhibition in 1898.

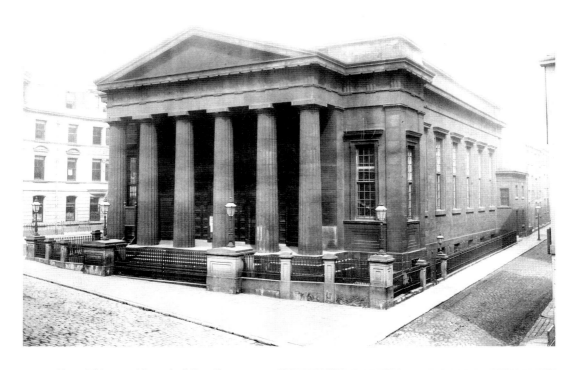

Above: This magnificent building, East Parade chapel, once stood on the site between Greek Street and Russell Street on East Parade. It was designed by Moffat and Hurst of Doncaster and the foundation stone was laid by Edward Baines in September 1839. The chapel opened for worship in January 1841 and could seat 1,600 people. It was demolished in 1899 to make way for the North British and Mercantile Assurance Company, which in turn was replaced by the Guardian Royal Assurance building.

Right: This marked an important stage in the development of the Greek Street area as the business and commercial sector of Leeds. It was opened on 2 May 1967 by Lord Blackford, chairman of the Guardian Assurance Company, and cost £500,000 to build. In the 1990s, this dull sixties building underwent a major refurbishment both internally and externally and emerged as the far more graceful and elegant Minerva House.

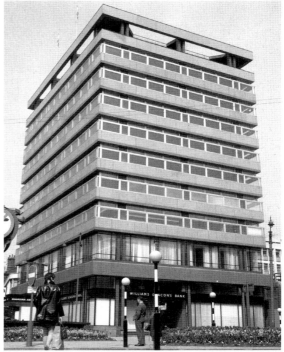

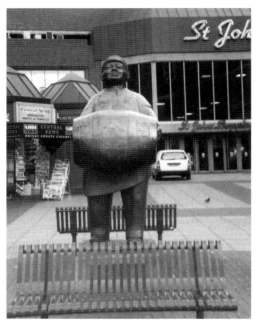

Left: The Dortmund Drayman was erected in Leeds in 1980 to celebrate ten years of being twinned with the German city. It is a copy of an original erected by the Altien Brewery in Dortmund and was unveiled by its sculptor Artur Schultz Engels in September 1980. The pedestrian precinct was renamed Dortmund Square in honour of the anniversary and was inaugurated by the then civic leaders, Oberburgermeister Samtlebe and Lord Mayor Eric Atkinson .

Below: Henry Moore (1898-1986) laid the foundation stone of the Henry Moore Sculpture Gallery on 10 April 1980, and had donated over £2 million pound's worth of his sculptures to Leeds City Art Gallery, including the striking form of Reclining Woman 80, which was placed outside the entrance. Castleford-born Moore attended Leeds College of Art and was fascinated by the human figure. He was given the freedom of the city in 1981.

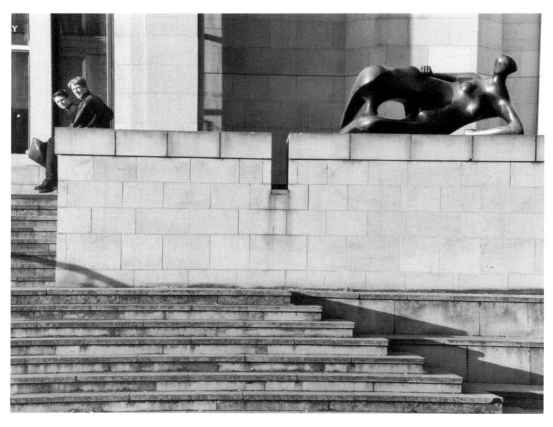

The Appeyards Building on Eastgate Roundabout, originally a petrol station, was built in 1932 and designed by Sir Reginald Blomfield, presumably to finish off the distinctive look of the new Headrow. For many years this was Appleyards petrol station and lay empty until the late 1990s when it was restored and developed into a fountain feature, with a sculpture of Leeds war hero Sgt Arthur Louis Aaron to one side. Sgt Aaron was awarded the Victoria Cross and the Distinguished Conduct Medal, and the sculpture depicts him surrounded by children.

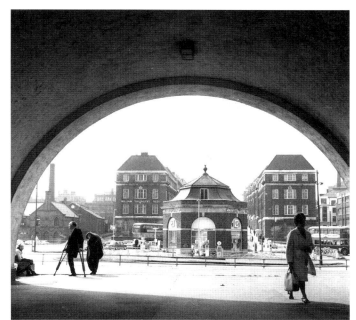

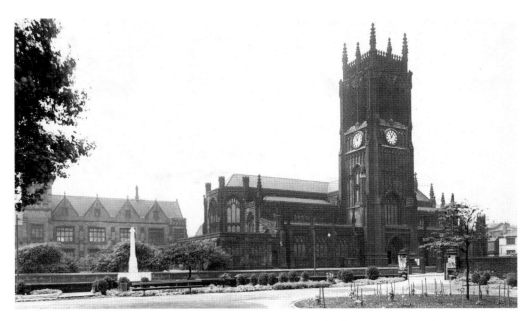

There has been a church on this site since the seventh century. The first one was a simple wooden structure that burned down in AD 633. The Domesday Book refers to a church in the manor of Leeds in 1086, but this too was burned and a new one built in the fourteenth century. By the time Walter Farquar Hook became Vicar of Leeds in 1837, this old building was in a dangerous condition, and the architect Robert Chantrell was commissioned to design a new one. Dean Hook told him to build a church that would hold as many people as possible and the finished church had seating for a congregation of 1,600. The parish church of St Peter's was consecrated on 2 September 1841.

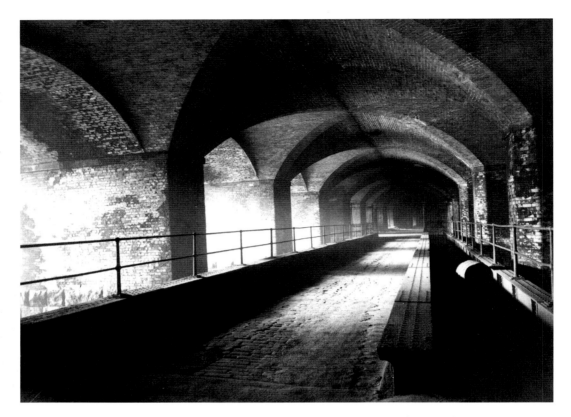

Hidden away from view, but nevertheless one of the most striking and dramatic features of Leeds, are the Dark Arches. Leeds city station is built over a series of arches, which channel the River Aire and part of the Leeds & Liverpool Canal. The space created by the arches was originally used to store tallow, resin and oil and in 1892 these caused a fire which destroyed the bridge and the railway line over the canal. The bridge was rebuilt, and the line restored. Part of the space is now used to house a number of speciality shops, and is part of the Granary Wharf shopping area. The sight of dark rushing water pouring through the arches when seen from the bridge puts one in mind of scenes from a Dickensian novel.

Going out

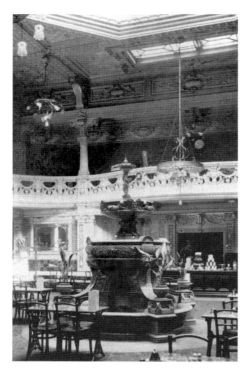

Left: The Ceylon Café owned by J. Lyons, in 1906. The café was very elaborately decorated with a large central feature of a fountain and an ornate ceiling, balcony and pillars. It also boasted a five-piece orchestra. This café originally opened in 1903 and closed in July 1938.

Below: The Kardomah Café on Briggate opened in 1908 and closed in August 1965. Here in July 1937 a sign visible in the window announces Kardomah Exhibition Tea Rooms. The Kardomah served a wide range of hot and cold snacks as well as a variety of teas and coffee.

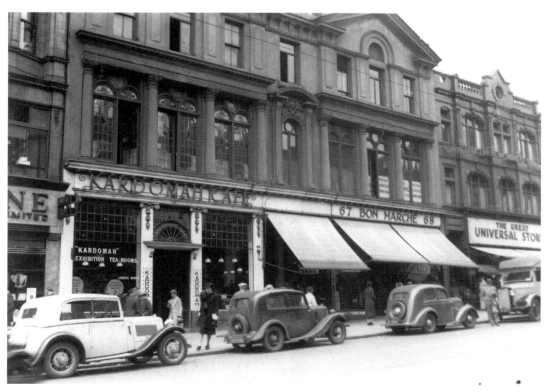

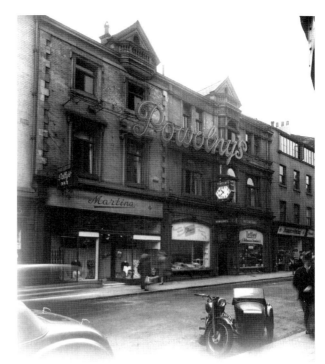

Powolny's Café seen here in June 1950 was at 5 Bond Street and was founded by Adolph Powolny. Another popular café of its day, this café opened in the 1850s and closed in 1960. Powolny's were official caterers when Queen Victoria came to Leeds to open the Town Hall in 1858 and again seventy-five years later in 1933 when the Civic Hall was opened by King George and Queen Mary.

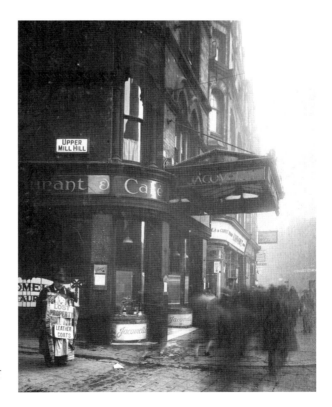

Jacomelli's Café on Boar Lane at the corner of Upper Mill Hill in 1931. It was opened in 1906 by Anthony and Francis Jacomelli and was originally called Jacomelli's Swiss Restaurant and Café. The firm was taken over by Hagenbachs in 1949 and became a Berni Inn in 1967. This building was demolished in 1973 for the building of the Bond Street Centre.

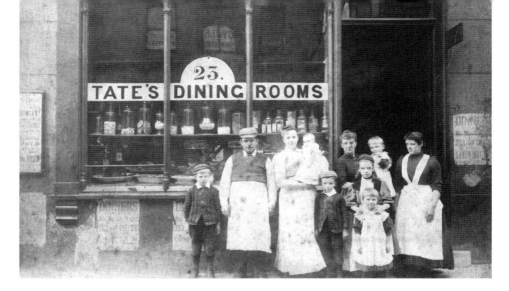

Tate's Dining Rooms on Lands Lane, with owners William Tate and wife Martha, their children and two others, early 1900s. On the far left is Thomas Tate, the eldest son, who assisted in the dining rooms which opened from 6 a.m. to 11 p.m. Thomas recalled: 'Although we called ourselves dining … we carried side lines ranging from sweets to snuff. I remember one very popular line, hair restorer, made by my grandmother, I don't know if it worked but people certainly used to buy it. The dining rooms were popular with workmen, theatregoers and the police. The police did not have a canteen in those days so they used to come to our place for a sit down and a mug of tea.' After the death of Mr William Tate this dining room closed and the family ran a similar business in Woodhouse Lane.

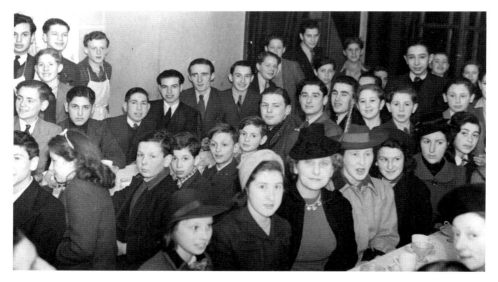

During the Second World War going out to eat was often a British Restaurant such as this one in the crypt of the Victoria Hall in the Town Hall. Seen here in 1942 it was set up as a wartime feeding centre where a cheap hot meal could be bought. The restaurant, also known as the Civic Restaurant, proved very popular, and was refurbished in 1960 and closed in 1966. The restaurant was split into two sections, self service and, the slightly more expensive, waitress service although the same menu was offered in each.

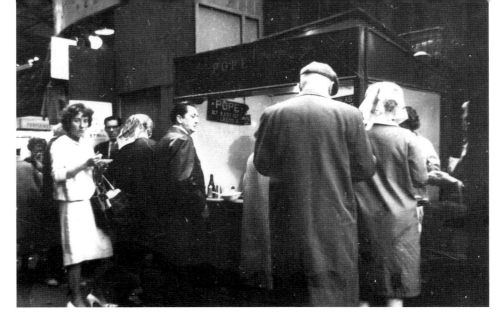

Sometimes 'going out' meant nothing more exotic than pie and peas! This undated image shows people queuing outside the Pope pea & pie stall located in Leeds Kirkgate Market.

This 1988 photograph shows Whitelocks, one of Leeds' oldest pubs, situated off Briggate in Turks Head Yard. The pub can trace its origins back to 1715 when it first became licensed to sell 'ale and porter'. The pub became known as the Turk's Head around 1784, hence the name of the yard. In 1880 it was bought by the Whitelock family and later became Whitelock's First City Luncheon Bar. This was the first place in Leeds to get electric lighting. Although the pub was rebuilt in 1886 it retains many original features.

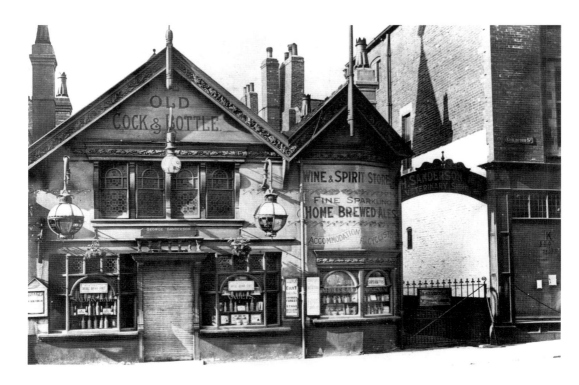

Above: The Cock and Bottle Inn was an eighteenth-century coaching inn on the junction of Upperhead Row and Guildford Street. The coach 'Eclipse' owned by Reuben Craven of the Woolpack Inn, Yeadon ran from here to Ilkley. It was sold to Snowden Schofield in 1938 and remained as part of Schofields store for some time but was demolished during extensions in 1961.

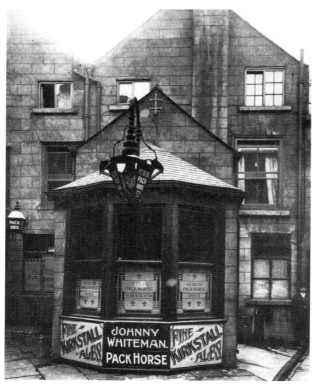

Left: The Pack Horse Inn in Pack Horse Yard between Nos 55 and 56 Briggate was reputed to be the oldest pub in the city at the time of this 1908 photograph. The inn dated from 1615 and was originally called the Nag's Head. It later became the Slip Inn before becoming the Pack Horse. A Templar cross is visible above the 'Pack Horse' sign. The old Pack Horse closed in 1987 and a new one was built on the site.

Above: An interior view of the Market Tavern on the corner of Harewood Street and George Street, taken in November 1914. It was built around 1806 as a private house and became a public house around 1850. It served traders and customers from the nearby market for well over 100 years. It had become affectionately known as the madhouse due to the larger-than-life characters that frequented it. Despite a campaign to keep it open it closed in 1995.

Right: This photograph from around the 1900s shows the Old George Hotel on Lower Briggate. First owned by the Knights Templar in the thirteenth century, the building displays Templar crosses on its front. Opened as the hotel 'Ye Bush' in the seventeenth century it became The George in 1714 and The Old George in 1815 when The George and Dragon opened nearby. It is sometimes referred to as Simpson's Hotel due to the Simpson family who ran it at the turn of the century. To the right of the public house the entrance to Old George Yard can be seen with the sign over the door 'R. Simpson, wine and spirit merchant'. The hotel closed in April 1919 after the license lapsed and the building was demolished soon after.

Another former coaching inn was the Bull and Mouth Hotel on the east side of Briggate between Kirkgate and Duncan Street. It was at first a centre for heavy baggage wagons; as the picture shows, the archway was originally much wider to accommodate the huge wagons. It became a coaching inn in 1800, and the Loyal Duncan was the first coach to run from here. It soon became one of the busiest coaching inns in Leeds and had standing room for thirty horses in the cellar stables. In 1903 it became the Grand Central Hotel and in 1921 the name was changed again to the Victory Hotel. It closed in 1939.

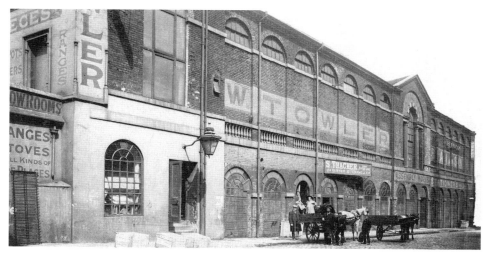

In Georgian Leeds, the nobility and gentry of the city required a centre for social engagements. The Assembly Rooms, which were built over the north wing of the Third White Cloth Hall in 1777, provided the perfect venue with a highly decorative ballroom and a suite of supper rooms and card rooms. By the mid-1800s the Assembly Rooms had been converted to a Working Mens Club before becoming William Towler's Globe Foundry Warehouse as shown in this view of around 1910. In the 1920s Hirst's Tobacco was here and changed the name of the building to Waterloo House. The building has now, however, been restored to its original function, as a venue for entertainment.

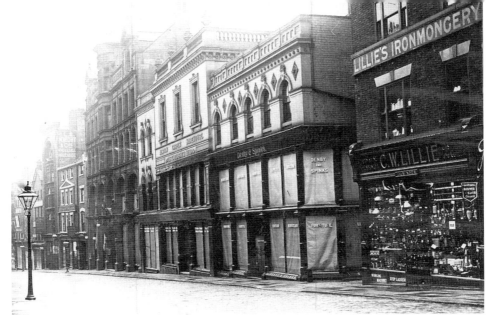

On 2 July 1792, the first stone of the Music Hall in Albion Street was laid. The ground floor of the building was used as a cloth hall. Sometimes called Tom Paine's hall, it provided accommodation for manufacturers who were excluded from the other cloth halls because they had not served as regular apprentices to the trade. Upstairs were a picture gallery, a lecture room, and a larger music saloon, where there was room for about 850 people. The hall had an orchestra and a gallery and from the arched roof hung glass chandeliers, each holding twenty-thirty candles. The Music Hall opened in January 1794. The hall was mainly used for public meetings and musical concerts as well as a wide variety of more unusual entertainments. With the opening of the Town Hall in 1858, the use of the Music Hall declined and it was closed in 1870. It was later bought by Denby & Spinks and used as a furniture store. The building was demolished in 1973 and the site is now part of the Leeds Shopping Centre and this space is occupied by British Home Stores.

The City Varieties Theatre began life as the White Swan coaching inn built in 1762 in a yard off Briggate. A singing room was added in 1766 establishing a tradition for entertainment. Charles Thornton who became the licensee of the White Swan rebuilt a singing room over a newer White Swan Inn that was opened as Thornton's new music hall in 1865. An additional entrance to the Headrow, seen here, was made in 1888. It went through various changes of ownership including a lease to John Stansfield giving Charles Thornton the money to create Thornton's Arcade. It was renamed Stansfield's Varieties before changing again in 1894 to the Leeds City Varieties Music Hall. The tradition of variety theatre was sustained by the famous 'Good Old Days' television programme that ran for thirty years from the City Varieties, starting in 1953.

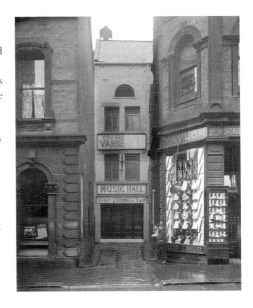

The finale of *Babes in the Wood* with Nat Jackley, 25 February 1961, and the last performance at the Empire Theatre before its closure. Designed by London architect Frank Matcham it opened on 29 August 1898 as the Empire Palace Theatre and was considered one of the country's finest music hall theatres. Seating 1,750 people on three tiers, it was visited by stars such as Charlie Chaplin and Gracie Fields. In 1960 Moss Empires planned to replace the Empire with another, larger theatre elsewhere in Leeds. This never happened and the theatre was demolished in January 1962. The site became the Empire Arcade and in 1996 Harvey Nichols occupied this spot.

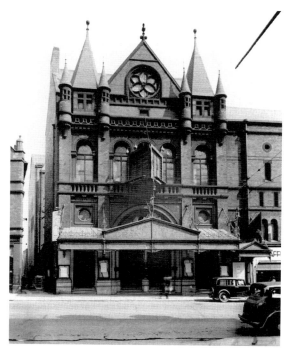

The Grand Theatre on New Briggate, seen here in 1936, was designed by George Corson and his chief assistant James R. Watson. The cost of the site in 1876 was £21,102. The facilities included an assembly room to seat 1,200 people and a large supper room, in addition to an auditorium with 2,600 seats and standing room for 200. Because of recent fires at other Leeds theatres the directors were keen to make the building safe. Wilson Barrett, the manager, remarked that 'if the stage were engulfed by fire, every gentleman would have time to light his cigar comfortably, give his arm to his lady love, and saunter pleasantly out of the building!' It opened on Monday 18 November 1878 with a production of *Much Ado About Nothing* put on by Wilson Barrett's own company. It became the home of Opera North in 1977.

Right: In 1956 the Theatre Royal was showing *Queen of Hearts* and displaying a sign claiming it was the most popular theatre in Yorkshire. The Royal Amphitheatre had previously been on this site but was destroyed by fire in 1876, a year after the old Theatre Royal on Hunslet Lane was burned down. Joseph Hobson rebuilt The Amphitheatre, and re-named it the Theatre Royal. Bradford theatre manager Francis Laidler leased the theatre in 1909 and his first Christmas production was *Babes in the Wood.* Under him the Theatre Royal became famous for its pantomimes, which were considered to be the most successful in the north of England. He died in 1957. It was later bought by Schofields and demolished when the Schofields Shopping Centre was built. The site is now part of the Headrow Shopping Centre.

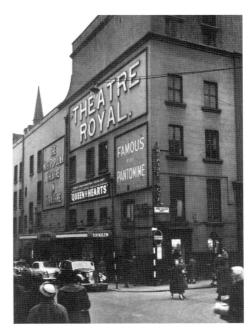

Below: The Gaumont cinema on Cookridge Street in 1946. This was previously the Coliseum, re-opened by the Prince and Princess of Wales when they visited Leeds in 1885. The hall was described as 'one of the finest in the north of England' by Kelly's Directory in 1914. There was a dress circle and an upper circle and the theatre held 3-4,000 people. There were refreshment and private function rooms. The Coliseum opened in April 1905 and the name changed to Gaumont in 1938 after it was fully converted to a cinema. It closed in 1969.

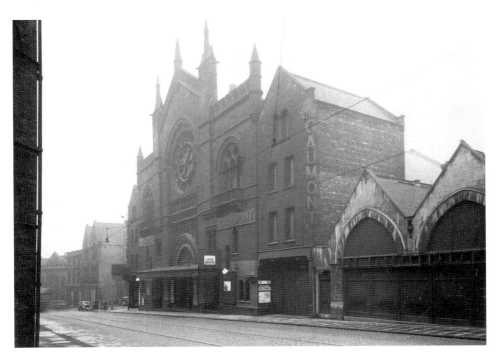

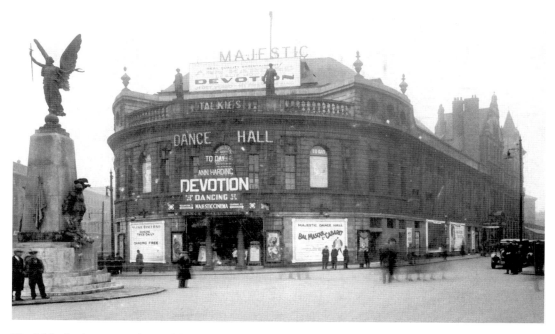

The Majestic cinema was designed by architect Pascal Steinlet and built in 1921 as a picture house. It opened on 5 June 1922. The previous building on the site was a recruiting office and the site of Eyebright Place. 'Eyebright' was the name of a healing well which had been opposite, in the vicinity of Aire Street. This photograph taken in 1932 also shows the war memorial in City Square: the Winged Victory by Charles Henry Fehr, later resited in the Garden of Rest on the Headrow and then replaced by the Angel of Peace in 1992. The cinema closed on 10 July 1969, after a final showing of Clint Eastwood in *The Good, The Bad and The Ugly*. It became a bingo hall and is now the Majestyk Nightclub.

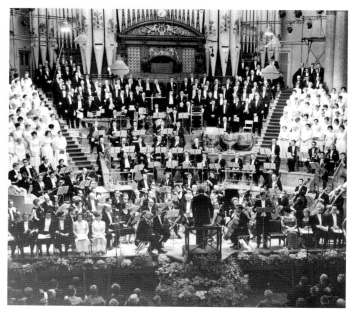

The Town Hall in April 1967 with the New Philharmonia Orchestra conducted by Edward Downes giving a performance of Prokofiev's War and Peace at the Trienniel Music Festival. The first Triennial Music Festival was held in the Town Hall after the opening in 1858. The conductor was William Sterndale Bennett and there was an audience of 4,000. The Town Hall has been the venue for musical concerts of all kinds and many leading conductors and musicians have performed here. It is also the venue for the finals of the Leeds Triennial International Piano Competition.

The News Theatre in City Square in 1953 just after the coronation. Pictures bearing the portraits of Queen Elizabeth and the Duke of Edinburgh are visible either side of a column with 'The News Theatre' written down it. Above the doors is a sign stating 'Special Coronation Newsreel'.

The Odeon cinema in 1946 with a clear view of the neon canopy, promoting the films *The House on Ninety Second Street* and *Sun Valley Serenade*. The cinema opened on 22 February 1932 and had a Portland stone façade to match the uniform design of buildings on The Headrow as set out by Sir Reginald Blomfield. The cinema also boasted a 17-ton Wurlitzer organ with 2,000 pipes and 160 stops worth £10,000 at the time. The cinema was designed by Frank T. Verity and seated 2,590. It became known as the Odeon from 1940.

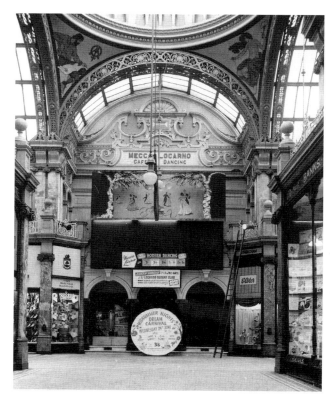

An early 1960s view looking from Cross Arcade into County Arcade to the front of the Mecca Locarno Ballroom. This dancehall opened on 3 November 1938 but in 1960 (Sir) Jimmy Savile became assistant manager playing popular records for the dancers. The Mecca closed in 1969. The central dome in the arcade, just in view, was decorated with figures representing Liberty, Commerce, Labour and Art. The arcade is now incorporated into the Victoria Quarter.

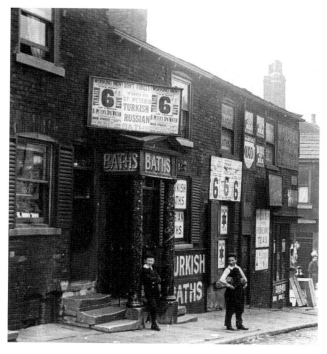

Leeds had several areas with curative waters, famous in their time. This site in the Quarry Hill area was thought to have been regularly visited by Leeds historian Ralph Thoresby. In 1858 two members of Leeds Foreign Affairs Committee opened a Turkish bath on this site, one of the first ten in England. It was extended backwards to gain frontage at No. 4 High Street. In 1870 it was named St Peter's Turkish Bath, then in 1876 the new proprietor, Tom Mountain, renamed it St Peter's Spa. It was lost when the area was redeveloped and the Quarry hill flats built.

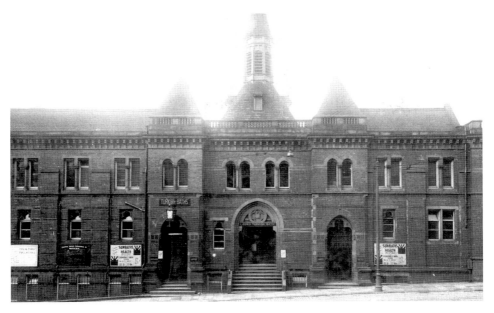

The Oriental and General baths on Cookridge Street, seen here in 1928, were designed by Cuthbert Brodrick. They cost £13,000 when built in 1867 and remained in use until 1965. There were separate entrances for men on the right, and women on the left. This site is now part of Millennium Square.

A roundabout and stalls at a Leeds fair just outside the city centre in around 1900. Fairs were held twice a year in the centre of Leeds from at least the fourteenth century; 10/11th July for horses then 8/9th November for farm staff and cattle. The latter were held on Briggate but gradually the fairs were moved away from the centre. Fields next to Black Bull Street in Hunslet were sometimes used or, as here, land off Camp Road. The livestock gradually disappeared and fairs became a source of entertainment and fun.

Left: Circuses in the nineteenth and early twentieth centuries performed in the city centre, often on Boar Lane. This circus bill dated for a performance on 12 March 1883 advertises Fossett's Circus. Other circuses to appear here included Pablo Fanque's, John Sanger & Sons and Franconi's Cirque National de France.

Below: This photograph shows a Burns Night celebration at the Metropole Hotel in 1925. Piping in the haggis is piper Merdock MacKay and the toastmaster (centre back) is William Scully.

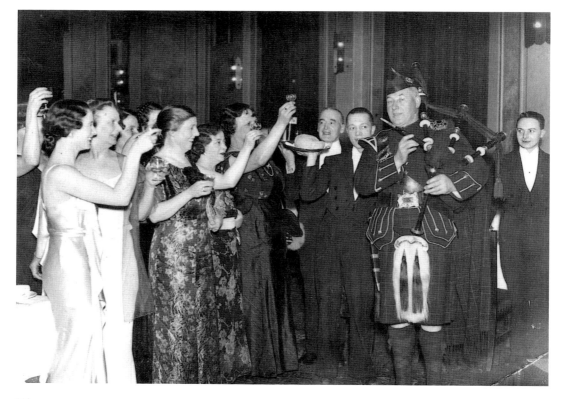

Events

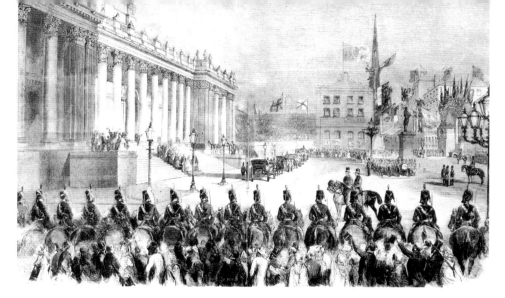

Queen Victoria visited Leeds in September 1858 to open the newly built Town Hall. *The Times* described the scene as the Queen left the station. 'Once her carriage was fairly seen outside the railway station, there arose such a cheer, as has seldom been heard before. It was a cheer, not only of the thousands to whom she was visible, but the cheers of all along the line of route; it was caught up and passed from street to street, and into places far removed from where the Queen would pass.'

The future King Edward VII, the Prince of Wales, visited Leeds on 19 May 1868 to open the Leeds National Art Exhibition. This was being held in the New Infirmary (now the Old Infirmary on Great George Street) and it was his first state occasion visit to Leeds. This engraving, which appeared in the *London Illustrated News* of 30 May 1868, shows the Prince's procession up Great George Street.

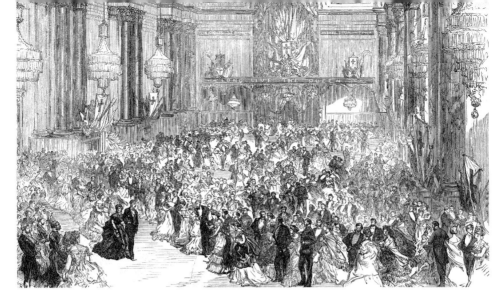

Prince Arthur, Duke of Connaught and third son of Queen Victoria, visited Leeds on 19 September 1872 for the opening of Roundhay Park. The event was marked with a reception at the Town Hall and a procession through the town centre. Mayor John Barran put on a ball in Victoria Hall and the Prince can be seen to the left of this picture, escorting the Mayoress. The purchase of Roundhay Park by Leeds Corporation in 1871 had been the cause of much controversy.

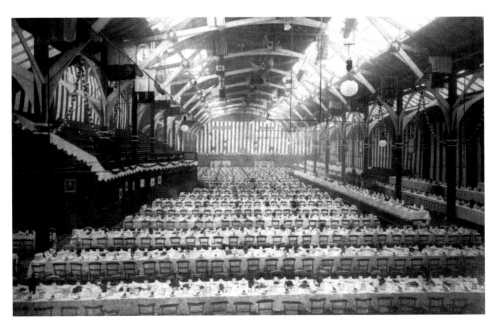

The interior of the Coloured Cloth Hall set out for Prime Minister W.E. Gladstone's address to the Liberal Party in Leeds in 1881. This temporary building was erected in the courtyard of the Coloured Cloth Hall to seat 2,000 people for a banquet on the first evening of his visit, which took place on the 6 and 7 October. Mr Gladstone arrived in Leeds to a hearty reception by the people and the newspapers reported that the approaches to the station were thickly lined with people for hours before the train was due to arrive.

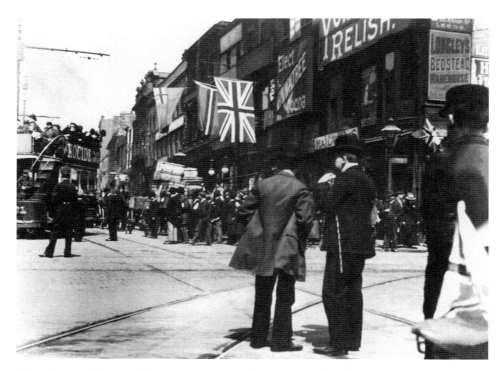

Above: News of the end of the twenty-seven-week-long siege of Mafeking reached Leeds late in the evening of Friday 18 May 1900. *The Yorkshire Post* reported that 'Quite half an hour elapsed after the good news had been published before the long pent-up spirits of Leeds people found vent… the enthusiasm came like the pop of a drawn champagne cork'. This image shows the decorations that appeared on Briggate at the junction with Duncan Street.

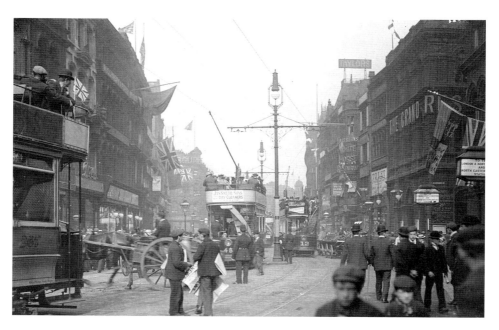

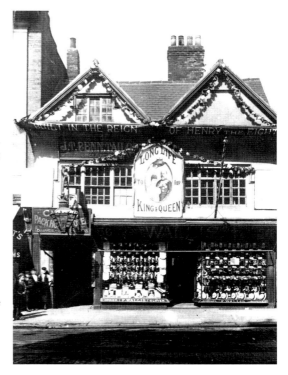

Right: These decorations were to celebrate the coronation of King Edward VII and Queen Alexandra. A banner proclaims that the building dates from the reign of Henry VIII. 'God save the King, long may he reign', 'Long life to our King and Queen' declare other loyal decorations. On the left is the entrance to Pack Horse Yard. The inn dated from 1615, when it was the Nags Head. The name later changed again to the Slip Inn.

Below: An unusual and rare shot of the Black Prince statue being constructed *in situ* in City Square, in 1903. The sculptor was Thomas Brock and the statue had been paid for by Col. Thomas Harding. The Black Prince was chosen (somewhat controversially) to symbolise chivalry, good government, patronage of the arts and education, encouragement of industry, and democratic values. The statue was unveiled on 16 September 1903.

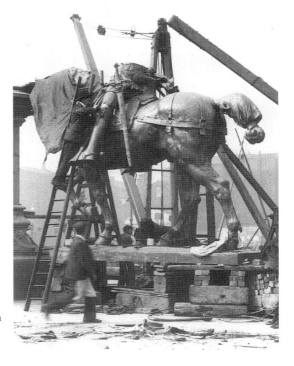

Opposite below: The signing of the Peace of Vereeniging on 31 May 1902 marked the end of the Boer War. The people of Leeds responded to the news with all the joy and enthusiasm they had shown when Mafeking was relieved a couple of years earlier. *The Yorkshire Evening Post* gave an exciting description of the news breaking: 'The news of peace reached Leeds at about 6 o'clock last night. At that hour, a messenger from the General Post Office ran breathless into the office of *The Yorkshire Post* inquiring whether Lord Kitchener's dispatch had come to hand. The tube which connects the two offices was immediately set working, and out dropped the all-important telegram which set Leeds agog with excitement'. Here we see Boar Lane, with flags decorating the buildings, and people out on the streets, taking in the news.

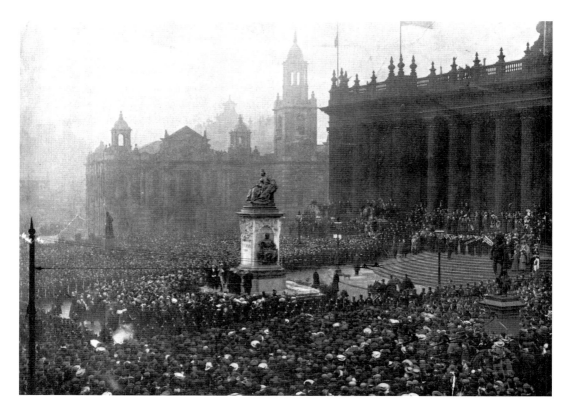

Above: Crowds gather in Victoria Square for the unveiling of the statue to Queen Victoria. The sculptor was George Frampton RA and the statue was unveiled by the Lord Mayor of Leeds, Mr Edwin Woodhouse, on 27 November 1905. The finished statue was over 30ft in height and was thought to be the tallest example of a memorial to Queen Victoria, apart from the one outside Buckingham Palace.

Left: A postcard view of Leeds showing the decorations to mark the royal visit on 7 September 1908 of King Edward VII and Queen Alexandra. The building frontage is that of R.B. Brown & Sons, wholesale clothiers, Nos 21–23 Wellington Street. Every window is crammed with excited workers eager to get a glimpse of the royal pair who were in Leeds to open a new wing of the university.

The Leeds City Transport Parade at the start of a solemn ceremony on the first Armistice after the Great War, laying a wreath outside the Tramway Offices on Swinegate. King George V requested that the people of Great Britain maintain a two minute silence on the eleventh hour of the eleventh day each year to mark the deaths of the millions of men and women who died fighting for their country.

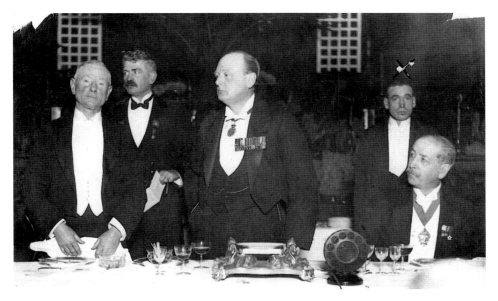

In 1926, the guest of honour at the annual Leeds Incorporated Chamber of Commerce dinner was the Rt Hon. Winston Churchill, Chancellor of the Exchequer. The country was still recovering from the after effects of the war and the economy was struggling. Churchill was welcomed by the Hon. Sir Gervase Beckett MP with a warm speech, to which he responded with a lengthy speech of his own, outlining the government's ongoing plans for the economic recovery of the country.

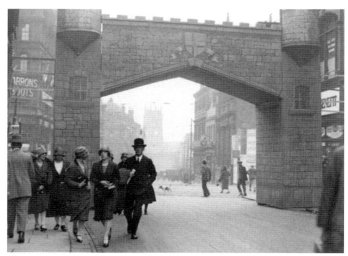

The Leeds Charter of Incorporation was granted by Charles I on 13 July 1626 and the city fathers decided to celebrate the 300th anniversary in style. The celebrations lasted for a week, from 8 July to 17 July 1926. The programme of events included open days at various council departments, such as the gasworks and sewage works, and a tour of the ring road! In this photograph, Kirkgate has been transformed into a medieval castle, along the top of which two soldiers in period costume patrol.

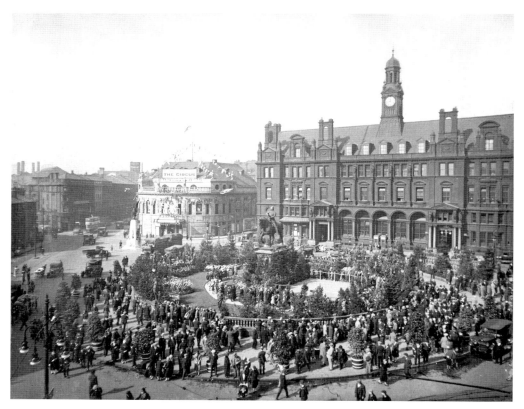

Civic Week in Leeds celebrated the industrial and economic growth of the city, to instil a sense of civic pride into the people of Leeds. In 1928, Civic Week kicked off at 11 a.m., Saturday 22 September, on the steps of the Town Hall. The centre of Leeds was once again decorated with flags, bunting and flowers, although the *Yorkshire Evening News* criticised some streets for 'not pulling their weight'! City Square, in this photograph, was transformed into a garden, and was adorned with lawns, flowers and small trees.

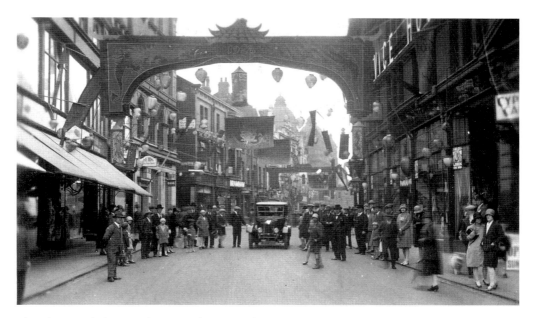

This photograph shows Kirkgate as 'Chinatown' during Civic Week festivities. Dragons, pagodas and strings of lanterns can be seen across the street. Another slogan for Civic Week was to allow the citizens of Leeds 'To Maintain and Develop their Civic Heritage'.

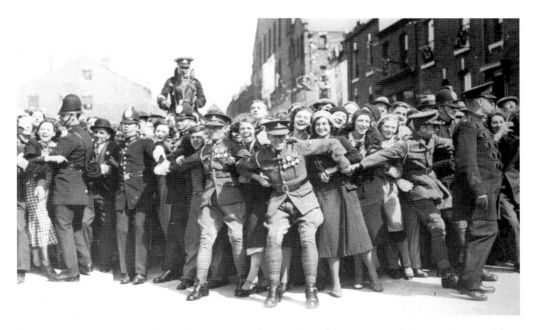

Soldiers and policemen hold back the crowds on the occasion of the opening of the new Civic Hall by King George V and Queen Mary. The day was glorious, with hardly a cloud in the sky, as King George opened the new building with a special golden key. The hall was built in only three years, and surviving members of the building workforce were invited back for the Golden Jubilee celebrations in 1983 to witness the unveiling of a plaque and attend a special lunchtime reception in their honour.

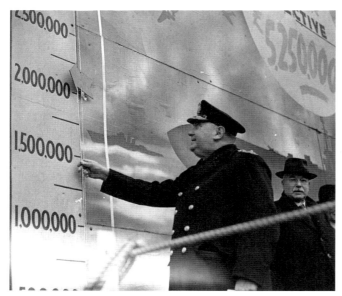

Admiral Sir Thomas Spence is seen here moving the target indicator to officially launch *Ark Royal* Week in Leeds in 1942. The original *Ark Royal* aircraft carrier was sunk by enemy action off Gibraltar and the people of Leeds, during Warships Week in 1942, raised a total of £9,300,000 towards the cost of a replacement. This was a staggering sum of money and represented a contribution of over 40% of the total cost. Furthermore, the money had been raised in the short space of one week! Contributions ranged from children's pocket money to donations of around £250,000 from businesses.

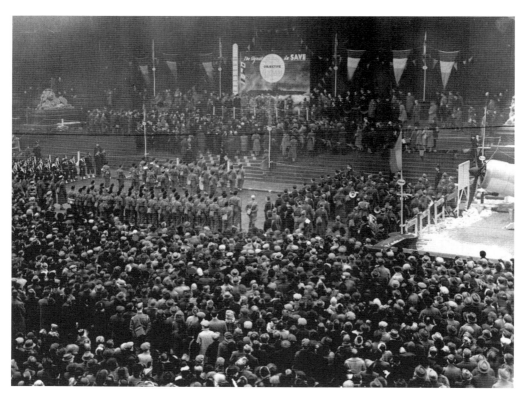

General Charles De Gaulle was in Leeds on 6 February 1942 to inaugurate Allies Day. He was invited to make a speech and to move the target indicator showing how much money had been raised towards the cost of the new *Ark Royal*. Wild cheering broke out when he announced that their fund-raising activities had improved the previous days' efforts by a grand total of £2,124,287!

Salute the Soldier Week was a fund-raising event undertaken by towns and cities all over Great Britain to raise money for the war effort. The target for Leeds was £6 million, which would send 100 divisions to Berlin. The final total was nearly £7 million. The Chancellor of the Exchequer Sir John Anderson came to Leeds to launch the event and spoke of the huge expense of the war. It had so far cost £1,000 million pounds a year, he said. In this photograph, taken on 3 June 1944, we see a military parade on Boar Lane.

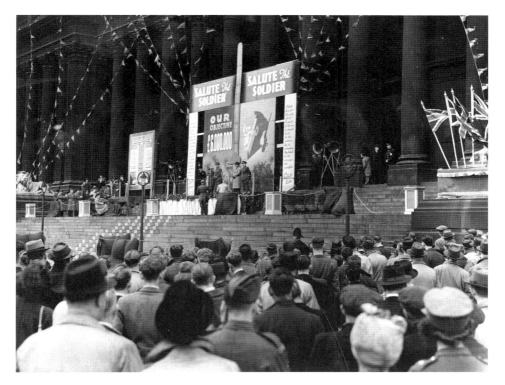

Leeds Town Hall decorated with flags and bunting as Major General Shears makes a speech in 1944 in which he emphasised that saving at this juncture would not only encourage the soldiers with the knowledge that the civilian community was supporting them, but would provide the means for giving the finishing blows to the enemy. Much depended on the result of this effort, he said, because the people of Leeds represented one of the leading cities of the country.

The unconditional surrender of the German forces came about on 7 May 1945 and the next day was declared Victory in Europe Day. Thus ended six nightmare years of misery and hardships. Celebrations went on all night in some quarters and street parties were the order of the day for communities to celebrate. Large crowds attended a victory thanksgiving service outside the Town Hall, when entertainment was provided by a Scottish drum and pipe band that gave exhibitions of Highland dances. In this photograph a group of men from a Scottish regiment perform a sword dance on the steps of the Town Hall to the delight of the crowd.

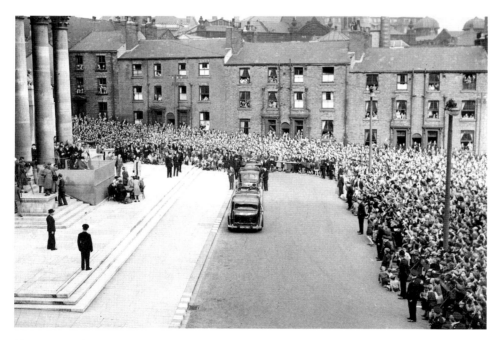

Sir Winston Churchill visited Leeds on 26 June 1945 as part of his election campaign. He can be seen here on a platform on the steps of the Civic Hall addressing huge crowds of people who had turned out to see him. Churchill was a national hero when the war ended but was overwhelmingly defeated in the General Election on 5 July 1945.

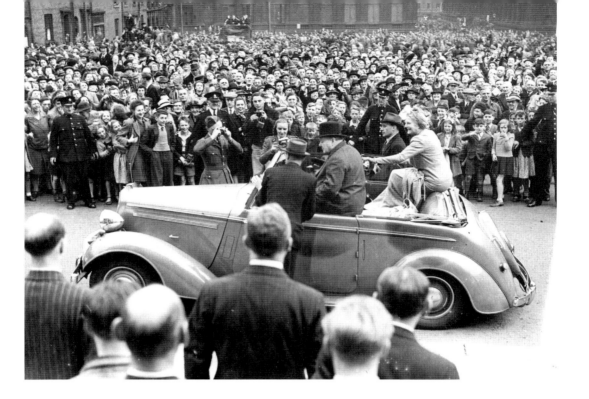

Above: Sir Winston and Lady Churchill wave to the crowds from their open Daimler car. They are perched on the backs of the seats so as to make themselves more visible to the cheering crowds. Churchill gave a speech from the steps of the Civic Hall which was largely drowned out by affectionate cries of 'Good old Winnie!' and 'Good old cigar!' The crowds swept aside police barriers so that they could get a better look at the hero. Churchill was given the freedom of Leeds on 28 October 1953.

Right: The future Queen of Great Britain visited Leeds on 27 July 1949. At that time, she was still HRH Princess Elizabeth. She and the Duke of Edinburgh, themselves new parents, emphasised that they wanted the tour to be for and about children. When asked what they would like to see during their tour, the Royal couple said, 'Let us see the children'. Princess Elizabeth and the Duke of Edinburgh went to Roundhay Park to watch the Children's Day activities and were introduced to the Children's Day Queen for that year, Miss Joan Anne Thompson.

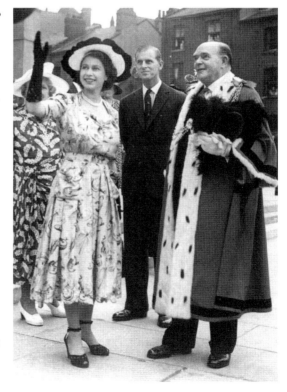

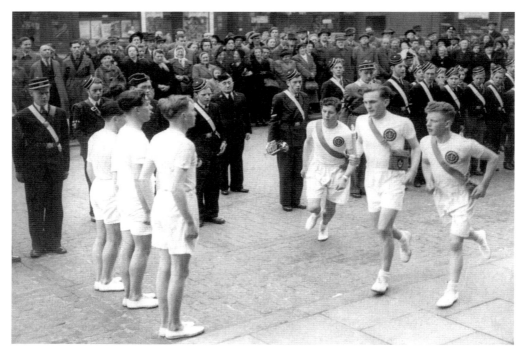

On 7 May 1952 a contingent from the 13th Company of the Leeds Boys' Brigade took over one of five batons containing loyal messages to the King. This took place in front of Leeds Town Hall, where the boys were received by the Lord Mayor Ald. F.H. O'Donnell. Trios of Boys' Brigade members carried the message from John O'Groats which would eventually be delivered to Buckingham Palace. Four other batons were delivered simultaneously from other parts of Great Britain. This trio, comprising Cpl G. Higgins, Sgt J. Badley and Lt-Cpl B. Parker, set off from the Town Hall and ran to Whingate Junction to hand it on to another trio. All five messages arrived at Buckingham Palace on 10 May 1952 and formed part of the Festival of Britain celebrations.

Left: The streets of Leeds were once again festooned with flags, bunting and every conceivable kind of royal decorations to celebrate the coronation of Princess Elizabeth in 1953. Two schoolgirls stroll past the banners in City Square which had a medieval theme for the occasion.

Opposite below: On 25 October 1973 the Queen Mother was in Leeds to see the Freedom of the City conferred on HMS *Ark Royal*. She is seen here being presented with a posy of flowers by seven-year-old Julia King, daughter of crew member Petty Officer Electrician Ian King.

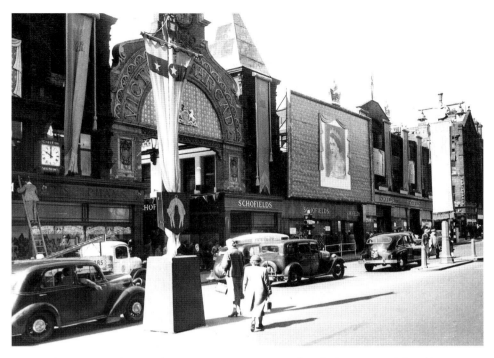

Above: The Headrow, showing the entrance to Victoria Arcade, which intersected the old Schofields department store. Down the middle of the road can be seen banners with motifs from the Leeds Coat of Arms and the store also has banners and panels with a fleur-de-lys pattern.

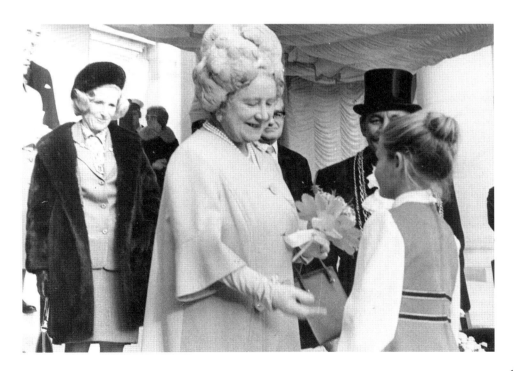

Other local titles published by Tempus

Haunted Leeds

KEN GOOR

From creepy accounts of the city centre to phantoms of the theatre, inns and hotels, *Haunted Leeds* contains a chilling range of ghostly phenomena. Drawing on historical and contemporary sources, you will hear about the Leeds Witch, the Beastie of Butts Corner, a former librarian who haunts the Leeds Library, the ghost of Bond Street shopping centre and many more ghostly goings on.

0-7524-4016-0

Leeds Cinemas

ROBERT E. PREEDY

With over 200 old photographs, programmes and advertisements, this book provides a fascinating look at the history of cinema-going in the city of Leeds and its suburbs over the last hundred years. It includes chapters on the technology behind the silver screen and the entrepreneurs and cinema chains which operated in the area. The images in this book will delight all those who have fond memories of visiting some of Leeds' picture houses, many of which disappeared long ago.

0-7524-3583-3

Around Garforth

GARFORTH HISTORY SOCIETY

This fascinating selection of over 200 old photographs and postcards comes from the archives of the Garforth Historical Society. This collection gives an insight into the lives and industries which have shaped the past of the area, taking the reader on a tour of former pits, schools and churches, remembering the struggles of wartime as well as celebrations, sports and recreation. This book will evoke nostalgic memories in older Garfordians and inform younger residents of their heritage.

0-7524-2614-1

Rothwell Volume II

ERIC BULMER AND ERIC WRIGHT

This wonderful second collection of images of Rothwell and the surrounding district revisits the lives of the people of this West Yorkshire village during the nineteenth and twentieth centuries, using over 200 photographs and ephemera to take the reader on a nostalgic journey into the area's past.

0-7524-3365-2

If you are interested in purchasing other books published by Tempus, or in case you have difficulty finding any Tempus books in your local bookshop, you can also place orders directly through our website

www.tempus-publishing.com